IMAGES
of America

FOUNTAIN HILL

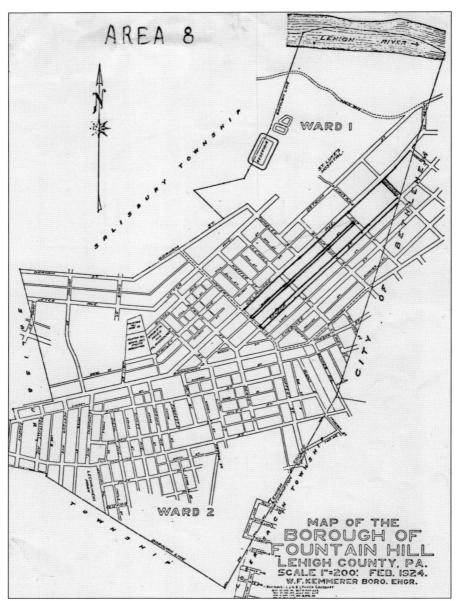

Borough engineer W.F. Kemmerer created this map of Fountain Hill in 1924, shortly after the annexation of 255 acres of Salisbury Township land more than doubled the size of the borough. With the inclusion of an additional 11 acres annexed on the western edge in 1949 at the request of land developer Phillip Ronca, the map continues to serve as the basic visual description of the borough's physical limits and features. (Courtesy of the Borough of Fountain Hill.)

ON THE COVER: The Fountain Hill Athletic Association, organized in 1921, was as much a social club as an athletic enterprise. Truman M. Dodson, chairman of the Parks and Playground Committee, encouraged the use of a large lot on the corner of Fiot Street and Delaware Avenue for the club's baseball and football activities. (Courtesy of John Bauman.)

IMAGES
of America

FOUNTAIN HILL

Karol Strelecki

ARCADIA
PUBLISHING

Published by Arcadia Publishing
Charleston, South Carolina

Printed in the United States of America

Library of Congress Control Number: 2014938392

For all general information, please contact Arcadia Publishing:
Telephone 843-853-2070
Fax 843-853-0044
E-mail sales@arcadiapublishing.com
For customer service and orders:
Toll-Free 1-888-313-2665

Visit us on the Internet at www.arcadiapublishing.com

Once a Hiller, Always a Hiller!

CONTENTS

Acknowledgments

This book has been made possible through the outpouring of support by present and former residents of Fountain Hill who have chosen to share their treasured memories of the borough. The donors include Lois Adams, Winston Alozi, Lois Brunner Bastian, John Bauman, Donald Benner, Jerry Berger, Judith Danner Bloch, Nancy Danner Behum, Donald Cerrato, Anna Corvino, Kevin Cyphers, Betty Jane Shaffer Damhosl, Donald Dimmick, Karen Tereska Drake, Edward Dreisbach, Roberta Ash Farrell, John F. Ferry Sr., Ned Fink, Martha Kapwell Fox, the Friedman family, Esther Overdorf Fesoli, William R. Fritz, Joseph Gatta, Lois Glazier, Gerald G. Guman, David M. Hassler, Pauline D. Holschwander, Luther Hottle, Robert L. Hunter, Karen Strelecki Jones, Michael Kapila, Sandra Kelly, Dennis M. Kery, Ida May Hagen, David Leidig, the Lo Piccolo family, Nancy Mackes, Guy and Mary Maioriello, Robert M. McGovern Jr., Raymond Metzgar, Barbara E. and Jean A. Miller, Paul E.G. Miller, John Mohap, Pauline Moser, Christine Murray, the Muhr family, Nancy J. Ruth Overdorf, Carmella Pheiff, Elsie Pribula, Ken Ranier, Edward Redding, Thomas J. Redding, Jean Gross Reinert, Stephen Repasch, Cynthia Reppert, Susan Reppert, William S. Sames, Karen Samuels, Neal Schlottman, Mary Jane Miller Scholl, Martha Schrempel, John L. Spadaccia, Robert Spirk, Jean Betsock Stillman, David Strelecki, Gavin Strelecki, James B. Taglang, Mary Theresa Taglang, Edward Vogrins, Barbara Weber Williams, Jane Ihle Weddington, and Kenneth Weid.

In addition, several local institutions and organizations have opened their archives to assist in capturing the essence of what is popularly known as "the Hill." This list consists of the administration and support staff of the Borough of Fountain Hill (Fountain Hill), the Bethlehem Area Public Library (BAPL), Fountain Hill American Legion Post No. 406 (Post 406), Cathedral Church of the Nativity (Nativity), Kidspeace National Center for Kids Facing Crisis (Kidspeace), the Fountain Hill Pharmacy (Pharmacy), the National Canal Museum (Bauman Collection), St. John's African Methodist Episcopal (AME) Zion Church (St. John's), St. Luke's University Health Network (SLUHN), St. Paul's Evangelical Lutheran Church (St. Paul's), St. Ursula's Catholic Church (St. Ursula's), the Fountain Hill Cemetery (Cemetery), and the Unitarian Church of the Lehigh Valley (UCLV).

INTRODUCTION

The geographic footprint and the spirit of the borough of Fountain Hill were borne of two powerful religious philosophies. The first of these was the sense of brotherhood and independence fostered among the Moravian community of Bethlehem since their arrival as a communal society on the banks of the Lehigh River in 1741. The other was the entrepreneurial spirit and social gospel of the early industrial entrepreneurs of South Bethlehem, as expressed through the development of what would become the Bethlehem Steel Corporation, and their practice of applying the wealth and power they accrued to provide for those in need in the community.

Much of the land on the south banks of the Lehigh River, some 274 acres, was purchased by the Moravian Brethren from John Simpson of London, England, in 1746. Later, they added additional lands to the west and south, which they held until 1848. The Moravian community divided these lands into four farms, the Fuehrer, Hoffert, Jacobi, and Luckenbach parcels, which they cultivated to provide self-sufficiency for the expanding community of Bethlehem and to raise funds for their ongoing missions among the Native Americans. A few log buildings, including that of the squatter Konrad Ritschy on the banks of the Lehigh River and that of Tobias Weber on the Emaus Road, were among the first in the area that was to become known as Fountain Hill.

In 1843, given the arrival of industry to what was being called South Bethlehem, along with an increasing inability to maintain the kind of closed religious community that they had originally established, the ruling council, the *Unitas Fratrum*, moved to abandon its landholdings, asking Phillip H. Goepp, their administrator, to dispose of those on the south side of the Lehigh. In a series of transactions, the westernmost farms, the Fuehrer and the Hoffert tracts, were conveyed into private hands and parceled out for development.

In 1846, Francis Oppelt acquired two acres of the Hoffert farm for the purpose of developing the Hydropathic Institute, where St. Luke's Hospital stands today. Often known as the Water Cure, the institute offered the pure waters of nearby springs in a regimen purported to alleviate the ailments of clients. Charles Tombler and his son Lucious purchased 139 acres of the Hoffert farm in 1848. Lucious sold 22 acres of his plot to Daniel Freytag in 1850. Freytag built the first permanent residence on it in 1851. The stone farmhouse was at the north end of Bishopthorpe Street. In 1788, at the western extreme of the area that drained into what would come to be called Fountain Valley Creek, Nicholas Doll built the second house on the farm he was developing, on what is now Dodson Street.

Augustus Fiot, a Philadelphian, bought the Freitag parcel as a summer home. After considerable development of the building and the surrounding acreage, he named the retreat Fontainebleau. Fiot died in 1866, and his estate, as well as other parcels in the area, became the property of Tinsley Jeter. As the Feuhrer farm developed into a village, Jeter encouraged its growth and named the development Fountain Hill. Whether this name was chosen in deference to Fiot's Fontainebleau or because of the numerous springs that issued from Ostrum's Ridge, on the north and south of the mountain in the opposite direction, is still a matter of good-hearted conjecture.

Simultaneously, with the growth of the Bethlehem Iron Works and other industry in South Bethlehem, residential expansion was occurring in the area between Wyandotte and Fiot Streets. The captains of industry and their plant managers began to build palatial homes in the Delaware Avenue area. This area, now designated as the Fountain Hill Historic District, shared the names of South Bethlehem and Fountain Hill. Robert H. Sayre built what is now considered the first modern suburban dwelling on the northwest corner of Delaware Avenue and Wyandotte Street in 1858. The houses of W.H Sayre (1862), John Smiley (1863), E.P. Wilbur (1864), Dr. Frederick Martin (1865), and G.B. Linderman (1870) were among the other structures that soon appeared. It was during this period that someone suggested the use of Native American tribal names for the streets.

There developed from this expansion a unique culture of industry, philanthropy, and community service that pervaded both the Fountain Hill Historic District and what was then called West Fountain Hill. Much of this centered around the Church of the Nativity, organized first in 1862 to provide an opportunity for worship following Protestant Episcopal precepts. From the congregation flowed additional initiatives: Lehigh University, Bishopthorpe Manor, St. Luke's Hospital, the Thurston Home for Children, the Fountain Hill Opera House, and numerous clubs, activities, and worship opportunities for a broad spectrum of the community.

In West Fountain Hill, a different kind of expansion was occurring. With the gentle but firm direction of Tinsley Jeter, who declared that Fountain Hill "is and will long remain a place of pleasant homes and the chosen home of St. Luke's Hospital," suburban housing development flourished, with projects defined as Fountain Hill Heights, Moravian Heights, the Wilbur Lawn Suburb, Norway Place, and the Lechauweki Springs Suburb. The Lechauweki Springs resort was thriving as a retreat for Bethlehem residents as well as visitors who now found the Lehigh Valley accessible by train. The Shive Governor Works, the Fountain Hill Vinegar Company, Jeter's Brick Yard, various silk mills, and stone quarries led the commercial growth.

By 1893, a distinct dichotomy was evident. Of a population of 1,200, a majority of freeholders supported a petition to form an independent town organization. On November 4, 1893, Lehigh County judge Edmund Albrecht handed down an opinion that created a borough with boundaries that began on the east at the point at which "the borough line of South Bethlehem intersects Emaus Road." This is just east of the intersection that is now Bishopthorpe Street and Broadway. The northernmost boundary reached to the middle of the Lehigh River. To the west lay the lands of Salisbury Township, at Hoffert Street. The first borough election was held on December 12, 1893, and resulted in the naming of Oliver H. Jacoby as the first burgess. The rapid adoption of borough ordinances set the tone and direction for the growing community.

In 1905, the South Bethlehem Development Council again proposed a jointure of the boroughs of Fountain Hill and South Bethlehem. The overture was again rejected on the basis that Fountain Hill had made as much, if not more, progress on its own than did South Bethlehem, and that the community was quite able to manage its growth and development. In fact, the borough was already looking westward and, by 1919, was able to annex a substantial segment of Salisbury Township that it abutted on its western border. An overwhelming majority of the freeholders in this area, which was already nominally considered part of Fountain Hill, signed the petition of annexation. This expansion completed the growth of the borough, with the exception of a small parcel adjoining Salisbury and Fountain Hill, the annexation of which was proposed by developer Phillip Ronca in order to complete his Roosevelt Terrace project in 1949.

Fountain Hill was now prepared to develop its own schools, public services, community organizations, and residential development to fulfill Tinsley Jeter's dream and progress to meet the criteria of "Home . . . School . . . Church" noted on the borough seal.

One

OUR HERITAGE

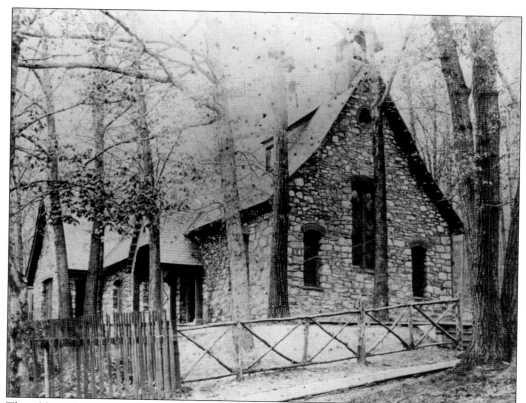

The oldest church building in the borough was the "rural church" of the Cathedral Church of the Nativity. Constructed in 1874 on a tract of land donated by John Smiley at the south end of Wilbur Avenue, near the entrance to the Lechauweki Springs resort, the church held services every Sunday afternoon until 1941. Robert H. Sayre donated $1,000 toward the building of the chapel. (UCLV.)

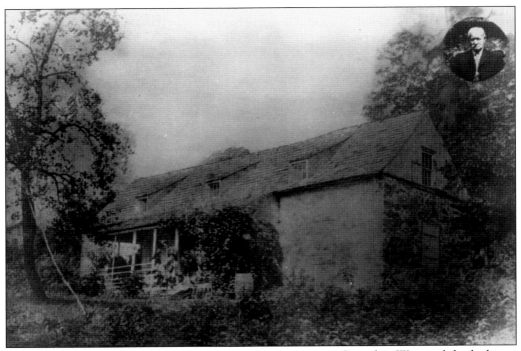

Cornelius Weygandt built this stone house in 1755 on 80 acres owned by George Hartman. It was rented to John Hoffert in 1810. The Hoffert family lived in it for 38 years. With significant renovation, it remains standing today, northeast of the terminus of Jeter Avenue. John Hoffert is seen in the inset of this image. (Bauman Collection.)

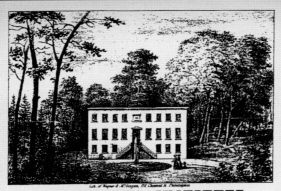

HYDROPATHIC INSTITUTE

AT THE LEHIGH MOUNTAIN SPRINGS, NEAR BETHLEHEM, PA.

Dr. F. H. Oppelt.

This establishment, which is in operation throughout the whole year, is most delightfully situated among the mountains on the banks of the beautiful Lehigh, in the vicinity of the pleasant town of Bethlehem. There are few more lovely and romantic spots to be found in the country, possessing in its promenades, under the shade of old forest trees, and among the ever-green laurels, with the noble view of the valley of the Lehigh, bounded by the circle of the Blue Mountains in the distance, the greatest attractions for the lover of nature, and tempting the invalid to that healthful exercise in the free and pure air, which is so necessary to the restoration of health.

The establishment is supplied with excellent spring water, pure and cold, having the inestimable advantage of an equable temperature, during, both summer and winter, and in great abundance.

The Baths are under the same roof with the boarding and lodging apartments, all warm and comfortable for the winter season, the **WAVE BATH,** is in the neighbourhood, one half mile from the establishment.

A GYMNASTIC APPARATUS and BOWLING ALLEY for the exercise and amusement of the patients, has been erected.

TERMS.—INCLUDING ATTENDANCE AND BOARD—$7 PER WEEK,

For persons provided with the necessary articles, viz : two large blankets, two to three comforters, or one feather bed, a coarse linen sheet, six towels, and some linen for bandages, and a Syringe. Persons not provided with the above articles can procure them in the establishment, at reasonable prices.

Communication from New York by Somerville Railroad and Easton Stage at 9 o'clock A. M. — From Philadelphia by Bethlehem Stage at 4 o'clock A. M., and Norristown Railroad and Emaus Stage at 9 o'clock A. M., Tuesday, Thursday or Saturday.

The precursor to St. Luke's Hospital, the Hydropathic Institute of Dr. Francis Oppelt, offered a recuperative setting with treatment using what was claimed to be chemically pure water from springs on Ostrum's Ridge from 1846 to 1871. In a time when such settings were in vogue, the reputation of Oppelt's water cure procedures drew patients from beyond the Lehigh Valley and as far away as Europe. (SLUHN.)

Francis H. Oppelt called himself "doctor," although he had no degree in medicine. A homeopathic practitioner, Oppelt believed in the virtues of bathing in and ingesting pure water as a cure-all. He initially erected a three-story building to serve as a health center. A plan for a bathhouse along the Lehigh River never came to fruition. The area of his property was popularly called Oppeltsville. (Fountain Hill.)

This bird's-eye illustration created in 1873 depicts the part of South Bethlehem that is now the Fountain Hill Historic District and defines its relationship to what would become the independent borough of Fountain Hill. Most of the houses and many of the streets shown are still in existence. (BAPL.)

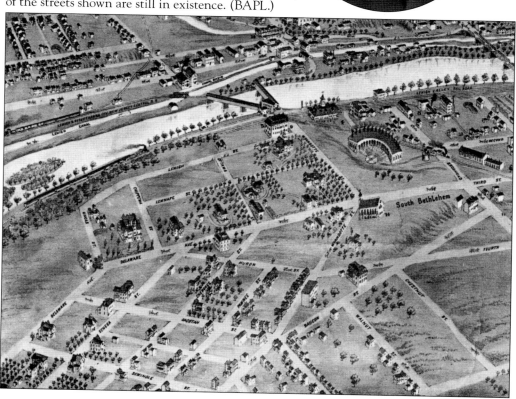

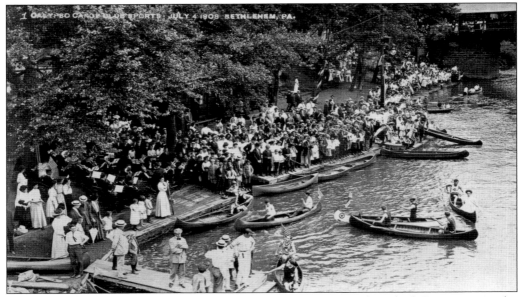

The Bethlehem Canoe Club frequented Calypso Island, a retreat in the Lehigh River, on a regular basis. They often ventured to the south bank of the river, from where they could access the hiking trails that led up the mountain to the park behind St. Luke's Hospital. Stone tables, fire pits, and freshwater springs made it a prime picnic area. (BAPL.)

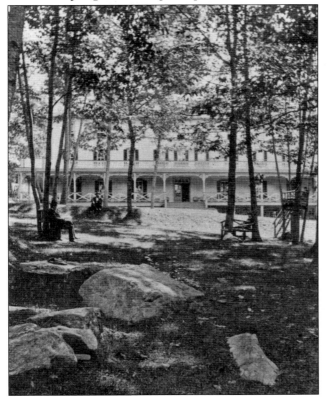

This view shows one of the several buildings that constituted the Lechauweki Springs resort. Built between 1873 and 1879, the hotel buildings contained not only guest rooms, but also parlors, dining facilities, and smoking and card rooms. No liquors were sold here. The grounds provided ample space for hiking and strolling. It was more than a summer resort; in winter, sleighing parties and indoor entertainment were offered. (Nativity.)

Guests at the Lechauweki Springs resort were treated to the finest of foods. Menus included items like ox tail soup, blenquette of veal, rice croquettes, and haricot of veal, along with a plethora of vegetables, relishes, and pastries. Tables were elegantly presented with condiment sets like the one pictured here. (Bauman Collection.)

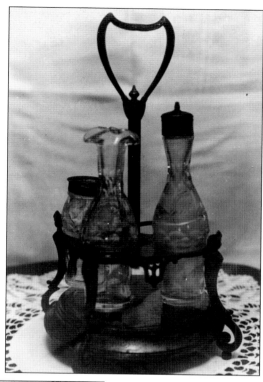

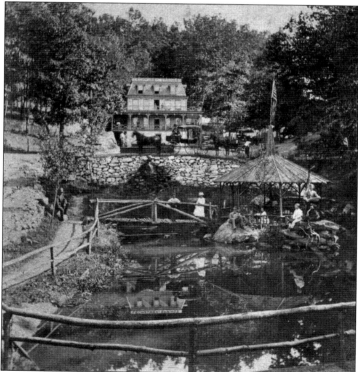

This image of John Smiley's Lechauweki Springs resort was taken from a stereoscopic set used as a promotional piece for the resort. In it are the main hotel building, at the headwaters of one of the springs; the coaches provided to carry visitors to and from the park; the fish pond; and a handsome, restful gazebo. (BAPL.)

The provision of sumptuous and healthful meals required a ready supply of fresh foods. While local farms provided daily deliveries, some storage was required. Refrigeration for the various hotels and cottages of the Lechauweki Springs resort was provided by a series of underground cellars, each cooled by a freshwater spring. (Gavin Strelecki.)

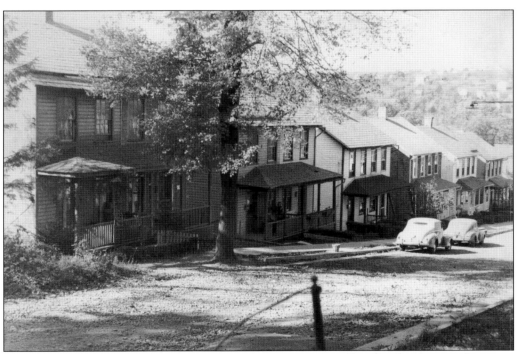

These six structures, seen as double houses in 1934, were originally offered as cottages for guests at John Smiley's Lechauweki Springs resort. In 1872, when they were built, the street on which they were sited was still named Wilbur Avenue, the name assigned by Salisbury Township before the 1919 annexation. (Edward Redding.)

James Miller, who owned considerable land in the Lechauweki Springs area of West Fountain Hill, provided bottled fresh spring water from the Lechauweki Spring to its clients. In preparation for the liquidation of some of his holdings, he posted this bill of sale throughout the community and South Bethlehem. (Mary Jane Miller Scholl.)

PUBLIC SALE

...OF...

Farm Stock and Household Goods

The undersigned will sell at Public Sale, at his residence, at

Lechauweki Springs

On the South Bethlehem-Allentown Trolley Line, on the public road between the Children's Home and Bitting's Hotel, on

Saturday, Mar. 23, '12

At 1 o'clock P. M., the following, to wit:

TWO GOOD DRAY HORSES

1 Fresh Cow and Calf. 2 Cows, Fresh in July. 10 Pigs ranging from 50 to 150 pounds apiece. FINE BRED POULTRY--2 Pens Ringlet Barred Plymouth Rocks; 6 pens fine White Leghorns; 1 pen Brown Leghorns; 1 pen Black Minorcas; 50 good laying hens, mixed stock. 2 good Heavy Wagons, set Hay Ladders, 2 Wood Racks, 2 Thrashing Machines with Shakers, 2 sets of Heavy Harness, 2 Heavy Chains each 15 feet long, lot of Shovels and Picks, large "National" Cream Separator, etc.

Household Goods

Consisting of 2 full Bedroom Suites, White Enameled Bed with Brass Trimmings, 3 Bed Springs, 2 Mattresses, 3 large Rocking Chairs, 6 Dining-room Chairs, 2 Parlor Tables, large Dining Table, Chiffonnier, large Parlor Mirror, large Iron Clock, 6 large Pictures, 3-plate Gas Stove, Bake Oven, 2 Taborettes, 2 Lamps, large Hanging Lamp, Vases, Bric-a-Brac, etc. Also FINE COUNTRY HAMS, Shoulders and Bacon, and a lot of Vinegar.

TERMS: 4 months credit.

A. A. Ackerman, Auct. **JAMES M. MILLER**

Wm. F. Lee, Printer, Iron Hill, South Bethlehem, Pa.

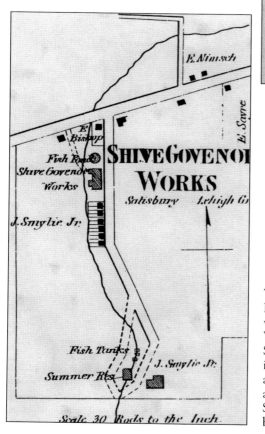

The first industry in what was to become Fountain Hill, the Shive Governor Works, was erected by John Smiley in 1873 on Wilbur Avenue, along the Lechauweki Spring. Production at the plant, which included the Shive steam engine governor as well as Bouy's Patent Counter Scale and a lawn sprinkler patented by John S. Cox of Bethlehem, provided a brisk business until 1888. (Fountain Hill.)

The Bishopthorpe Manor School for Girls owed its existence to the foresight and vigor of Tinsley Jeter and Rev. William Bacon Stevens. The two men convinced leading members of the Cathedral Church of the Nativity to support the concept of an exclusive school for girls. The school operated from 1868 to 1930 on land and in buildings that later became the St. Luke's Hospital School of Nursing. (Bauman Collection.)

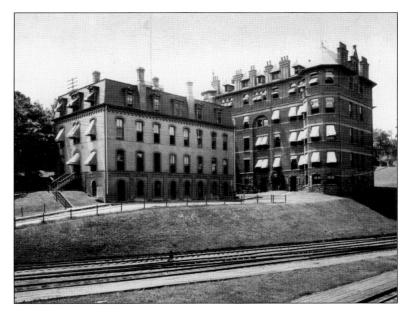

Reflecting the economic success of South Bethlehem, E.P. Wilbur erected the building on the left in 1871 to house his banking business. Three years later, the building on the right was created to serve as headquarters for the Lehigh Valley Railroad. Both are on Brighton Street, just south of the Hill to Hill Bridge. (Bauman Collection.)

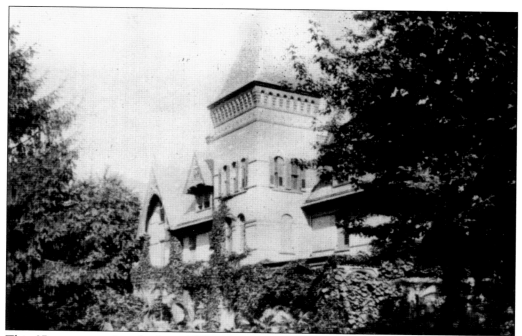

This 27-room mansion, built in 1870 at 577 West Third Street, was the home of Garrett B. Linderman, the first general manager of the Bethlehem Iron Company. Later, it became the home of Charles M. Schwab, founder and first president of the Bethlehem Steel Corporation. It is representative of the lifestyle of luxury enjoyed by the residents of the Fountain Hill Historic District. (Bauman Collection.)

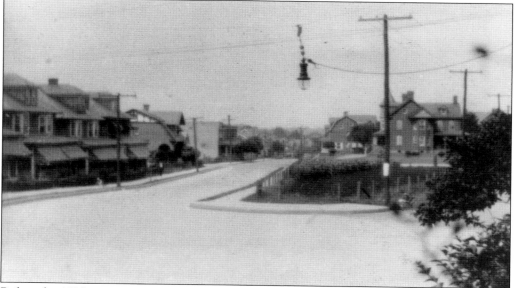

Before the 1923 annexation of a portion of Salisbury Township, the triangle at Broadway and Itaska Street, which would later become highly commercialized, is seen as a garden plot, with the Hellener farmhouse in the center background. Benner Avenue, which is also part of the intersection, was then called Stoney Lane. (John Spadaccia.)

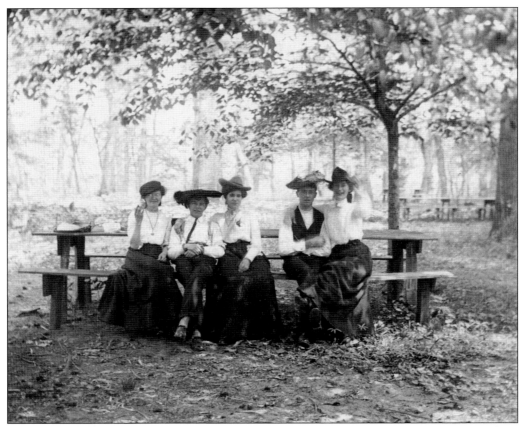

Matilda Bauman hosts a group of friends for an outing at Calypso Island. Bauman was the matriarch of a Fountain Hill family that was active in the school, church, and political fabric of the borough. While this group of ladies was limited, it was not unusual for families, churches, and other organizations to bring hundreds to the river retreat. (Bauman Collection.)

During the 60 years that Charles C. Tombler spent in the Lehigh Valley, he was a significant factor in transforming the Fountain Hill area from farm to suburb. Merchant, land developer, and politician, his most memorable contribution to the borough was the building of a farmhouse near the Weygandt residence, which was later transformed into the Fontainebleau mansion and eventually became Bishopthorpe Manor. (Fountain Hill.)

Two

OUR CHURCHES

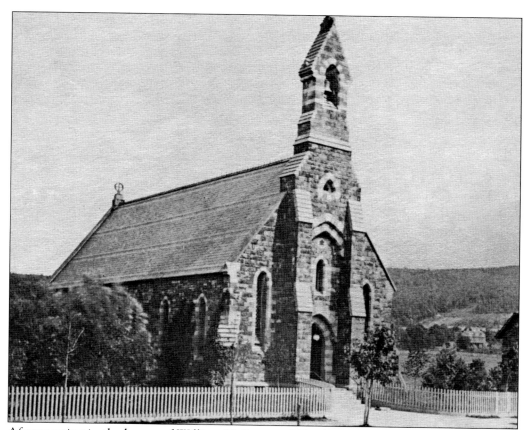

After meeting in the homes of William H. Sayre and Tinsley Jeter from 1860 to 1864, the first church building of the Parish of the Nativity was consecrated in 1865 by William Bacon Stevens, the bishop of Pennsylvania, on an acre of land across from Sayre's house. Rev. Eliphalet N. Potter became the first rector of the church. (Nativity.)

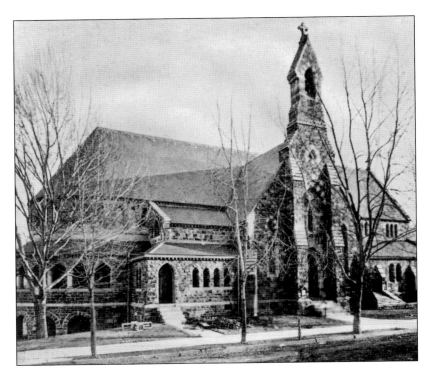

The congregation of the Cathedral Church of the Nativity expanded significantly from 1865 to 1885. An addition to the original building with many memorials was consecrated in 1887. In 1890, the vestry granted the Cathedral Church of the Nativity to the bishop of the diocese as a pro-cathedral. It holds this honor to the present time. (Nativity.)

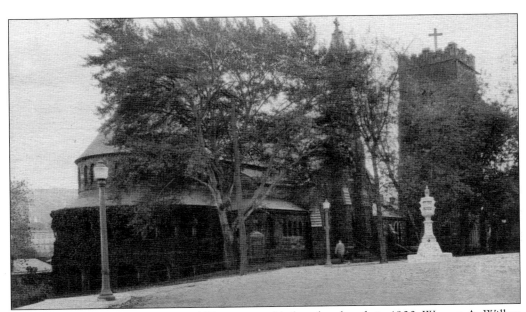

The Sallie Packer Wilbur Memorial Tower was added to the church in 1900. Warren A. Wilbur donated funds for the tower in memory of his wife. The belfry houses nine bells that collectively weigh 10,507 pounds. They are set to chime in the key of E flat. (Nativity.)

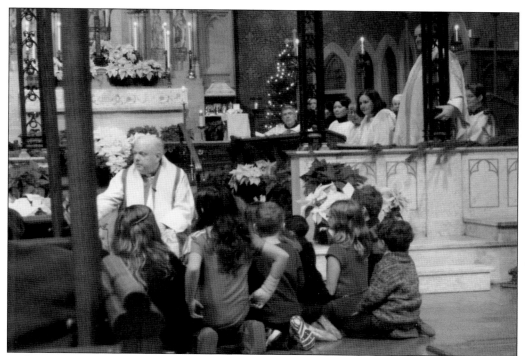

Right Rev. Paul Marshal offers a children's sermon in a traditional celebration of the Christmas season. The provision of both religious and secular educational opportunities for members of all ages and the unchurched of the South Bethlehem neighborhoods helped to establish Cathedral Church of the Nativity as a pillar of the greater community. (Nativity.)

Leonard Hall, in the 900 block of Delaware Avenue, was created in 1908 as a home for young men pursuing sacred ministry through the Episcopal Church. Land for the building was donated by Mr. and Mrs. G.B. Linderman, and the building was a gift from Mrs. Eckly B. Coxe. Bethlehem Preparatory School and Lehigh University agreed to provide tuition-free education as needed by the postulates. (Nativity.)

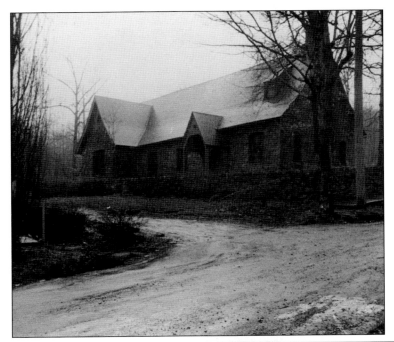

The Cathedral Church of the Nativity had two special outreach projects: St. Joseph's Chapel on Fourth Street in South Bethlehem and St. Mary's Chapel in Salisbury Township, near the entrance to the Lechauweki Springs resort. St. Mary's began as a series of Sunday school sessions first held in the main hotel building at the resort and later in the Jeter School on Seneca Street. (UCLV.)

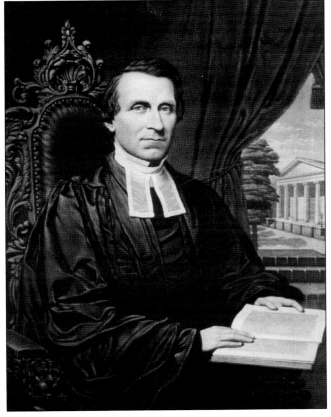

Rev. William Bacon Stevens was the fourth bishop of the Episcopal Diocese of Philadelphia and, in 1865, became the bishop of Pennsylvania. He was enlisted by Asa Packer to assist in the creation of Lehigh University in 1865 and supported Tinsley Jeter's proposal to establish the Bishopthorpe School for Girls. His devotion to education was confirmed when the borough of Fountain Hill named its new school building in his honor. (Nativity.)

The oldest congregation in the borough, St. Paul's Evangelical Lutheran Church, first organized in the Jeter School building in 1885. Services in both German and English were held there for several years. In 1890, a church building was erected on a Keiffer Street plot purchased from Tinsley Jeter for $500. The first service was held in February 1891. German services were curtailed in 1919. (St. Paul's.)

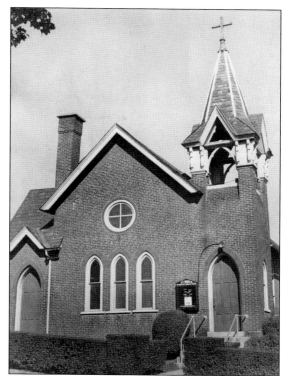

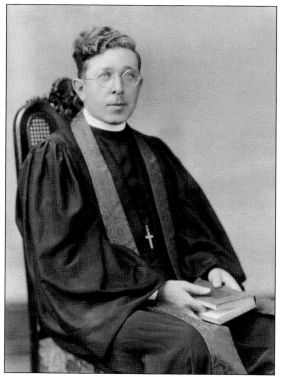

After 30 years of service by a part-time pastor, Dr. John A. Bauman of Muhlenberg College, the St. Paul's Evangelical Lutheran Church congregation called Rev. Ira S. Fritz, seen here, as its first full-time pastor in 1926. It is reported that, in the earliest years, Dr. Bauman often walked from Muhlenberg College to the Jeter School to lead the worship. (St. Paul's.)

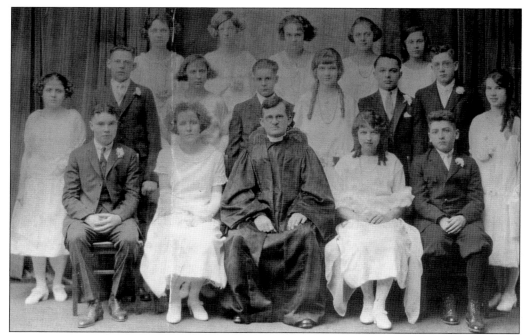

Rev. Melvin Kurtz, who served several Lutheran congregations in Bethlehem on a part-time basis, is seen here with the 1923 confirmation class of St. Paul's Evangelical Lutheran Church. In addition to providing religious instruction for the church's young people, Reverend Kurtz also filled in periodically for Dr. John A. Bauman. (St. Paul's.)

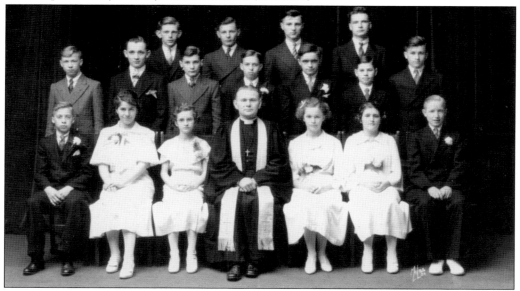

In 1930, Rev. Charles J. Shimer, seen here with that year's confirmation class, was called as the second full-time pastor for St. Paul's Evangelical Lutheran Church. Records at Kidspeace indicate that during Reverend Shimer's tenure, support for the children in placement expanded. A key effort was a Harvest Home service each fall, from which a collection of fresh produce and canned goods was donated. (St Paul's.)

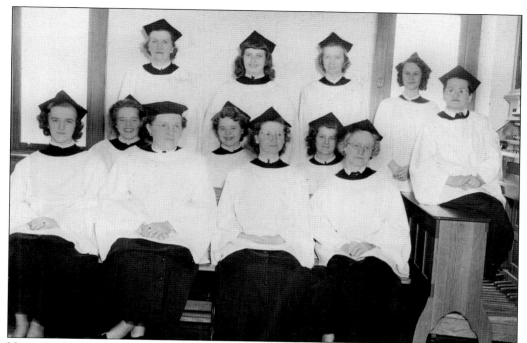

Verna Grube (far right), the longtime church organist and choir director at St. Paul's Evangelical Lutheran Church, prepares the ensemble for an Easter performance in 1946. The choir not only led worship in the church, but also performed in a variety of community events, including the annual Christmas tree lighting ceremony on Broadway at Lynn Street. (St. Paul's.)

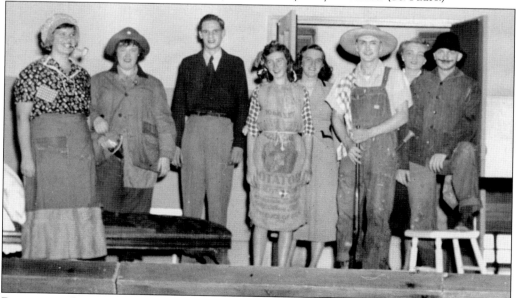

Dramatic and musical performances were a staple of many of the churches, schools, and social organizations of Fountain Hill. The cast of a production of the St. Paul's Drama Group takes a break during preparation for a performance on stage in the Stevens School Gymnasium and Auditorium in 1948. (St. Paul's.)

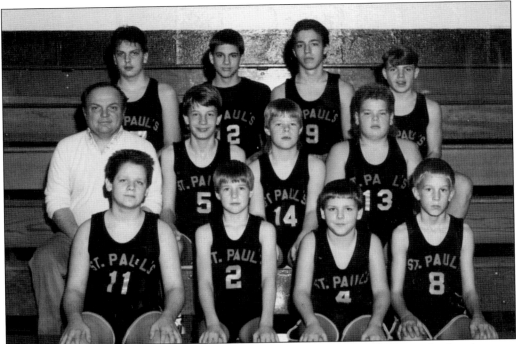

With no formal junior high school basketball program in operation in the borough, church teams, like St. Paul's, which played in the Bethlehem Church League, served as an opportunity for skill development and an outlet for the energies of countless teenage boys. Teams often included boys who were not members of the church. (St. Paul's.)

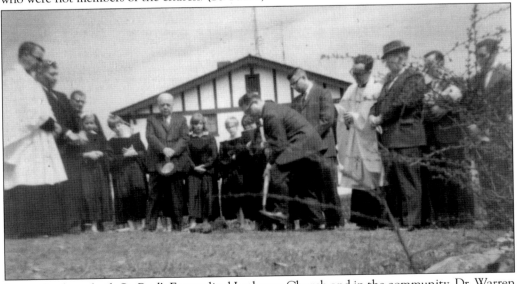

Long a leader at both St. Paul's Evangelical Lutheran Church and in the community, Dr. Warren A. Miller, one of the borough's corps of physicians, turns earth at the ground-breaking for a new church on Delaware Avenue. Directly behind Dr. Miller is Rev. Dr. Arvids Ziedonis, who served as pastor during the construction of the new edifice. Dr. Ziedonis also taught Russian studies at Muhlenberg College. (St. Paul's.)

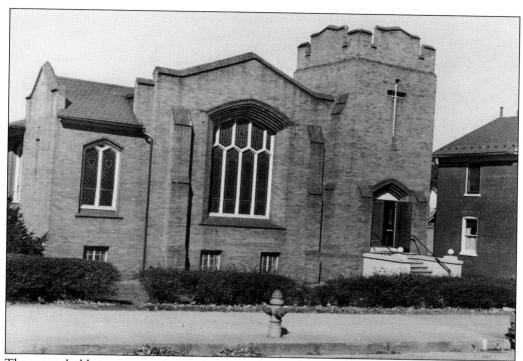

The second-oldest congregation in the borough was Grace United Church of Christ (UCC). The congregation first met in 1908 in a room at the Electric Laundry Company on Bishopthorpe Street before building a small church at 935 Broadway. In 1925, they erected the structure pictured here under the leadership of Rev. Theodore Brown, who dedicated his life to the church until his death in 1949. (Edward Redding.)

The 1953 confirmation class of Grace UCC speaks to the longevity of the congregation. This class was instructed by Rev. Harold R. Ash (rear, far left), who had accepted the leadership of the church in 1950. Reverend Ash, only the second pastor to serve at Grace UCC, also served on the Fountain Hill Board of School Directors. (Roberta Ash Farrell.)

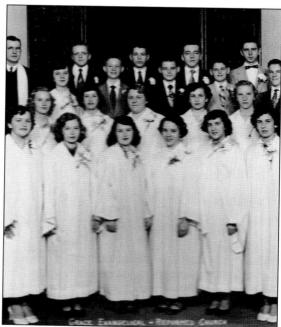

The St. Ursula's Catholic Church congregation celebrated its first Holy Sacrifice on December 14, 1919. The chapel in which it was celebrated was a converted garage at the corner of Alaska and Bastian Streets, two blocks west of the Five Points in South Bethlehem. Its rectory was located at 835 Broadway. (St. Ursula's.)

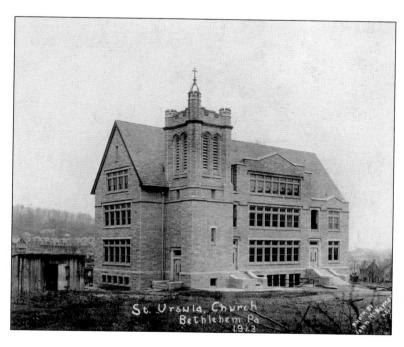

Nearing completion in 1923 on a tract on Broadway that was part of the former Sayre farm, St. Ursula's Catholic Church stands at the corner of Souix Street and what will eventually be named Greene Court, in honor of Right Rev. John P. Greene, its first pastor. No one is quite sure when the spire atop the bell tower in this photograph was removed. (St. Ursula's.)

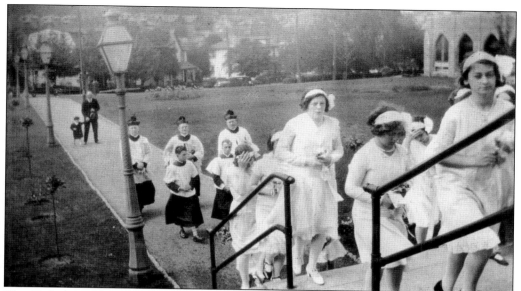

The Catholic tradition of honoring the Blessed Virgin Mary during the month of May was as strong at St. Ursula's Catholic Church as in many other parishes. The symbolic pilgrimage of the May Procession, seen concluding here on May 31, 1931, would culminate with recitation of the Hail Mary as well as special prayers and homilies. This custom fell out of practice in the 1970s. (St. Ursula's.)

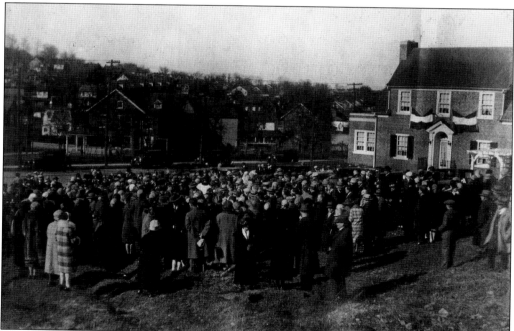

A crowd of parishioners fills the corner of Greene Court and Broadway as St. Ursula's Catholic Church breaks ground for the construction of a rectory and convent in 1927. To the right of the activity, the home of Benjamin Schrader, who served as the general contractor for the buildings, is patriotically bedecked for the occasion. (St. Ursula's.)

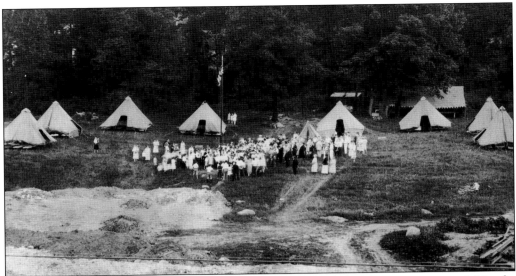

Beginning in the 1930s, St. Ursula's Catholic Church provided summer camping activities for both boys and girls on the level ground, now the parking lot, to the south of Souix Street. Both day activities and overnight camping filled several weeks each summer. Hiking along South Mountain and the former grounds of the Lechauweki Springs resort was a favorite activity of the campers. (St. Ursula's.)

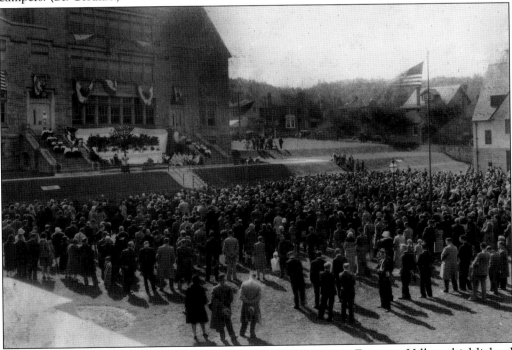

The 10th anniversary of St. Ursula's Catholic Church's presence in Fountain Hill was highlighted by a field mass celebrated by Right Rev. Charles B. McGinley. On this balmy spring day, it was held on the Souix Street side of the church, extending into the adjoining church property between Greene Court and Forrest Street. (St. Ursula's.)

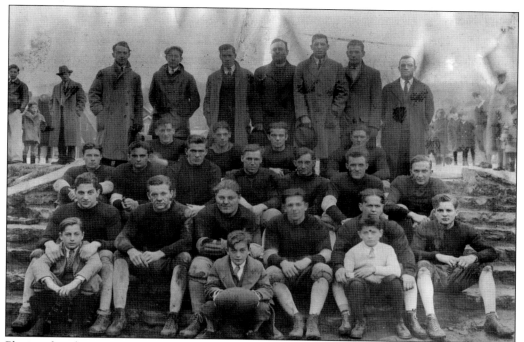

Playing their home games on a field that had been developed south of the church between Greene Court and Forrest Street, the 1946 edition of the St. Ursula's Catholic Church football club was the champion of the Bethlehem City Football League. In later years, football would become the province of the St. Ursula's Parochial School team, which carried on the winning tradition. (St. Ursula's.)

Unionization at the Bethlehem Steel plant led to some extended strikes. In a mutually beneficial arrangement, Rev. Joseph J. McPeak rallied striking church members to carry out renovations at the church while settlements were reached between labor and management at the steel plant. In return, the church provided varieties of support for the workers. (St. Ursula's.)

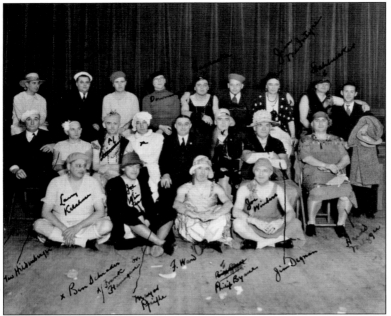

With the encouragement of Rev. Joseph J. McPeak and under the cloud of the Great Depression, the Drama Society offered what promised to be a most diverting affair in the borough in 1932, as an all-male cast presented *The College Flapper* in the church auditorium. The play was a farce comedy telling "the modern story of college life with many hilarious highlights." (St. Ursula's.)

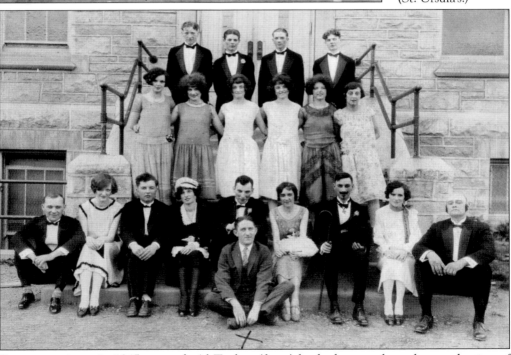

Drama continues in 1945 as coach Al Toohey (front) leads the cast through a production of *Harrigan*. The group included, from left to right, (first row) Hugh Howard, Mary Murin, Hugh Kelly, Anne Enright, Robert McGovern, Mary Howard, John Skully, Katherine O'Brien, and Earl Dredge; (second row) Mildred Redding, Dolores Enright, Elva and Edna Charlesworth, Lucy Kelly, and Anna Meno; (third row) Fran Rogan, Bernard Enright, Patrick Kelly, and Bill Enright. (St. Ursula's.)

An annual one-week summer carnival, held on what was formerly the football and baseball field south of the St. Ursula's Catholic Church, was a popular fundraiser for the church while it looked forward to an expansion of its facilities and a happy diversion for the borough's residents. Good food, rides, and a variety of entertainments filled the expectations of those who attended. (St. Ursula's.)

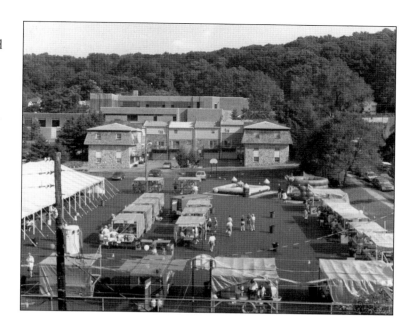

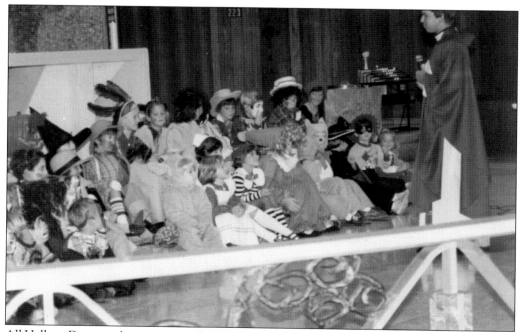

All Hallows Day is a solemn event on the church calendar, celebrating the lives of all saints, known or unknown. To help the younger members of the parish begin to comprehend its meaning, St. Ursula's Catholic Church celebrates a Halloween mass. Tying together earlier customs of seeking gifts with current trick-or-treat activities is an important part of the teaching process. (St. Ursula's.)

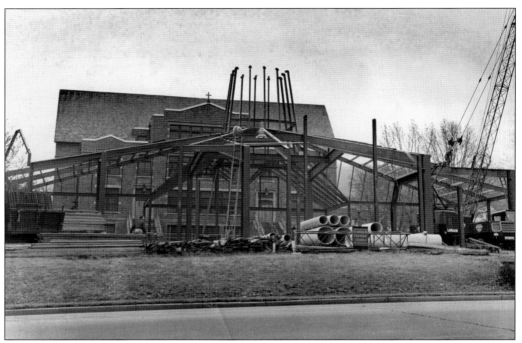

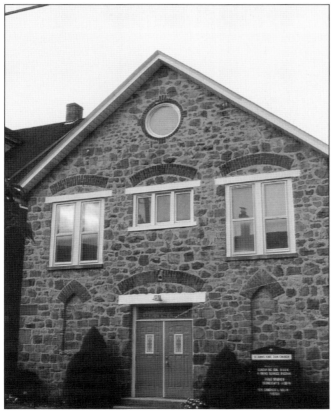

The superstructure of the new St. Ursula's Catholic Church building arises on Delaware Avenue in 1965. To assure that the new building would blend with the old, the new facade was constructed of the same Siesholtsville granite as the earlier structures. The laying of the cornerstone and the dedication of the church took place on May 30, 1967. (St. Ursula's.)

In 1894, a group of citizens of color, led by Elijah Watson, Victor Welch, Jonathan Certain, Ephriam Gould, and Benjamin Campbell, petitioned for incorporation as St. John's African Methodist Episcopal (AME) Zion Church. They met in various homes and even at the Bethlehem Police Station. In 1901, Rev. C.H. Brown dedicated a cornerstone for their place of worship at 718 Pawnee Street. (Winston Alozie.)

With the encouragement and guidance of Rev. Richard Christopher Columbus Jones, the senior choir of St. John's AME Zion Church reached for new heights in leadership of worship throughout the church year and especially at the major liturgical festivals. The choir's repertoire includes a wide range of traditional hymns and modern interpretations. (Winston Alozie.)

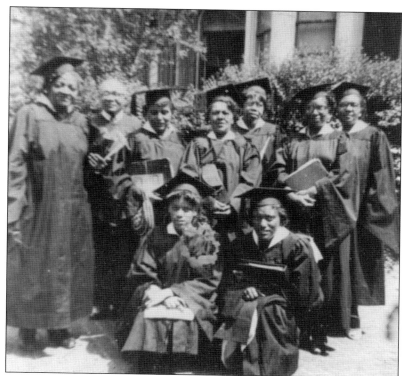

In 1930, Helena Boise Lightford took a strong role in leadership of St. John's AME Zion Church, singing in the choir and serving on the altar guild, the women's guild, and the Women's Home and Overseas Missionary Society. While women had always been active in the church, Lightford set a new standard for their participation. (Winston Alozie.)

A graduate of Liberty High School, Ada Brady was the second African American teacher hired by the Bethlehem School District. She taught kindergarten and first grade at a number of Bethlehem schools. At St. John's AME Zion Church, she served as the Sunday school pianist and was later named minister of music emeritus, a role she filled until her death in 2012 at the age of 91. (Winston Alozie.)

Sharing the joyous fellowship beyond the formal and structured service that is part of the worship experience at St. John's AME Zion Church are, from left to right, (first row) Belle Embry, Geraldine Cook, Donnell Bowie, Joan-Jenkins Smith, Rev. Nancy Hawes, and an unidentified guest; (second row) Rev. William Watson and Robert Miller. (Winston Alozie.)

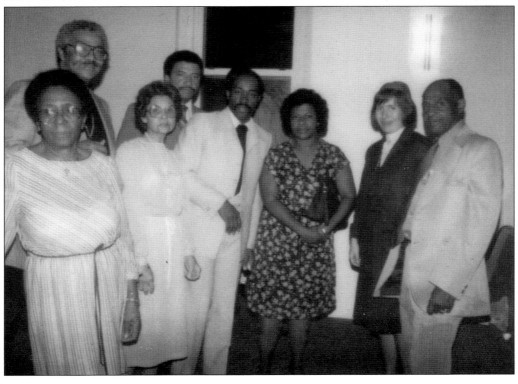

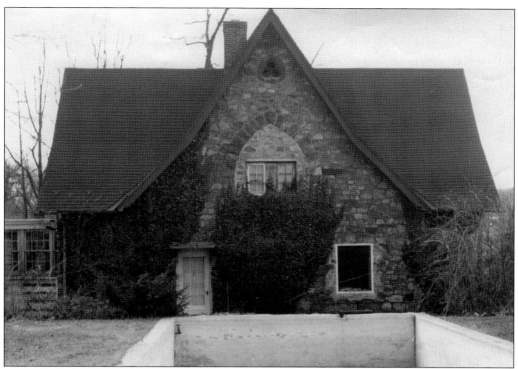

St. Mary's Chapel was inactivated in 1941 and sat idle until 1946, at which time Joseph N. Victor, a Swiss-born scientist doing work in ordinance, optics, and guided missiles, purchased it as a laboratory. He added space for experimentation and built the swimming pool seen in this image. After his death, the building remained unused until it was purchased by the Unitarian Church of the Lehigh Valley in 1958. (UCLV.)

The Unitarian Universalist Church, later chartered as the Unitarian Church of the Lehigh Valley, was first organized in 1948 at a meeting in the American Hotel in Bethlehem. Ten years later, it moved into the serenity of St. Mary's Chapel. Early membership lists include locally prominent names such as Hugh Moore, Frances Barnes, Althea Munro, Edward Donnelly, Edward Slifer, and Dr. Francis Trembley. (UCLV.)

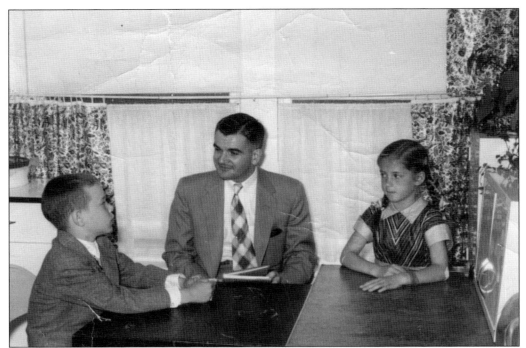

Religious instruction for children was a priority of the Unitarian creed. Here, William Marshall (left) is in discussion with Frank Laxar (center) and Pamela Davison (right). The church has also consistently provided a platform for liberal causes, hosting groups such as a Montessori school, the Lehigh-Pocono Committee of Concern, Turning Point, Le-Hi-Ho, and the Bail Fund. (UCLV.)

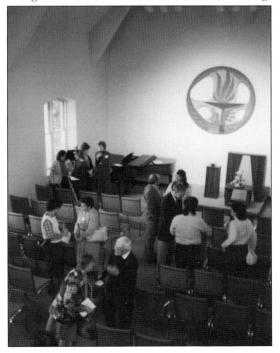

Interior renovations of the chapel by the Unitarian Church of the Lehigh Valley expanded the spaces already created by J.N Victor in order to provide more Sunday school and educational areas. The main meeting room was enhanced by the placement of a mosaic mural created by noted Lehigh Valley artist Raymond Gallucci. The flaming chalice in its center is a universal symbol of the Unitarian movement. (UCLV.)

Three

OUR SCHOOLS

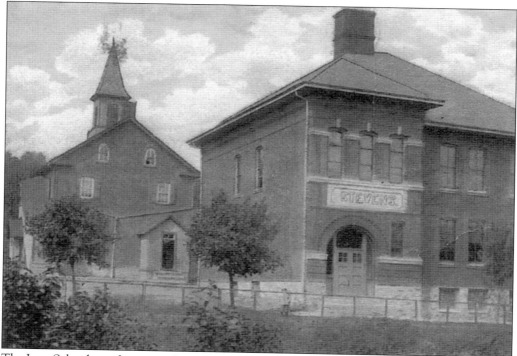

The Jeter School stands next to the emerging Stevens School before 1915 in this rare photograph. Built by Salisbury Township, the building also served Fountain Hill as the municipal building, a community center, and a place of worship. Simpson Brewer did the brickwork, while Levi Lynn was the carpenter for the construction. Toilet facilities were limited to two outhouses. (Fountain Hill.)

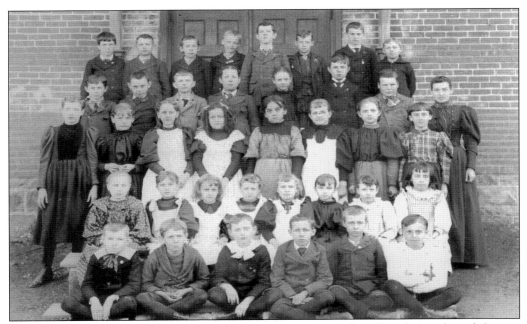

L. Kuhns (fourth row, far right) instructed the advanced primary class of the Jeter School in 1894. Principal A.R. Ritter reported that 18 students completed the course of study. The curriculum was divided into several levels during a school year that lasted 194 days. Kuhns was paid at the rate of $37.50 per month. (BAPL.)

The Jeter School, constructed by the residents of West Fountain Hill in 1880, served as the main community building for the area. Bernadine and Lucy McGovern, seen here at the front door, are two of the many students who attended classes at the two-floor, four-room school. Rooms on the second floor were divided by sliding doors. (Robert M. McGovern Jr.)

The Wilbur School, on the southwest corner of Souix and Lynn Streets, was named after South Bethlehem banker E.P. Wilbur. It came into the possession of Fountain Hill after the 1919 annexation of a portion of Salisbury Township. One of three elementary schools in the borough, it was touted as a school for "manual training." (Anna Corvino.)

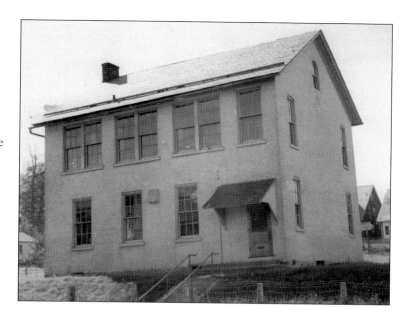

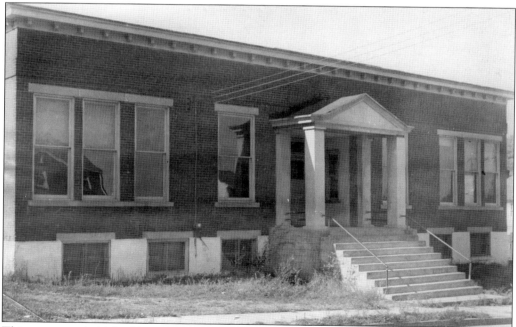

This two-room brick building on Hertzog Avenue was named the Wilson School in honor of the 28th president of the United States. After Fountain Hill's annexation of 255 acres of Salisbury Township, the school became the property of the borough. It was used primarily as an elementary school but was adapted for use as a youth center after World War II. (Anna Corvino.)

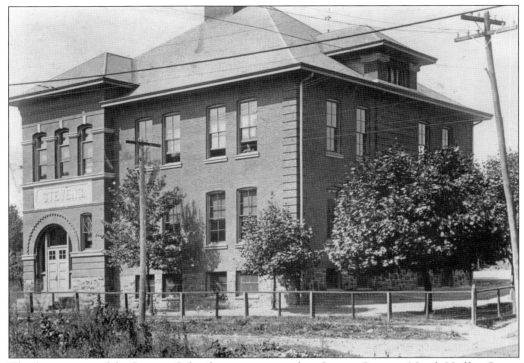

The first section of the Stevens School was constructed on Seneca Street at North Hoffert Street in 1905, adjacent to the 1880 Jeter School building. The new building consisted of two floors, with two rooms on each floor and a main hall and stairway. The winning bid for its construction, by Cornelius Beysher, was for $9,986. The bell from the Jeter School building was installed in its tower. (Fountain Hill.)

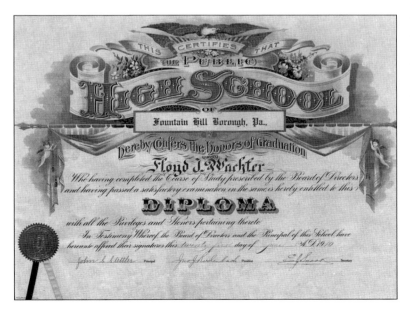

Until 1926, diplomas were presented to those students who successfully completed the program of studies at the Stevens School. The curriculum was equivalent to eight years of school attendance. Those who aspired to higher education enrolled as tuition students at Bethlehem High School, where they earned a four-year high school diploma. (Ronald Wachter.)

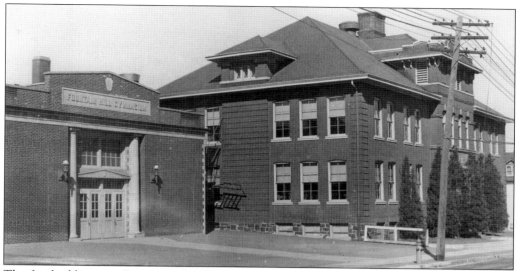

The final addition to Stevens School was the gymnasium, built on the site of the earlier Jeter School in 1924. The gym featured a parquet floor, an elevated running track, and a stage. Commencement exercises, previously held in the Jeter School building and sometimes at St. Paul's Evangelical Lutheran Church, were henceforth scheduled for the space, which also served as an auditorium. (Edward Redding.)

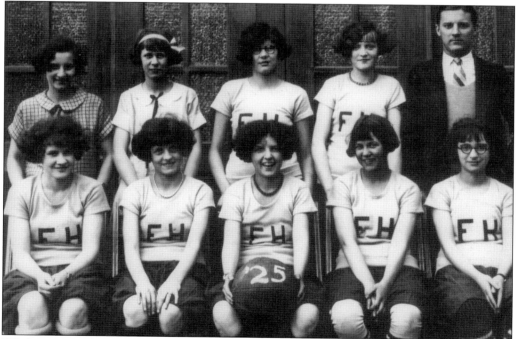

While organized athletic activities for females were limited under the Fountain Hill Athletic Association in the early years of the borough, the creation of a public school system provided an opportunity for participation by the school's female population. Shown here is the 1925 girls' basketball team. They played under rules that allowed six girls from each team on the floor at one time. (Edward Dreisbach.)

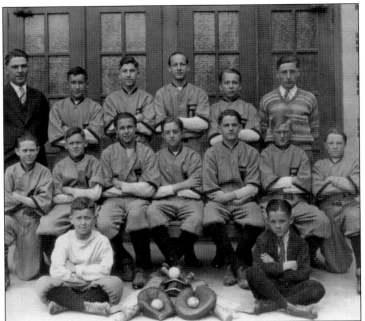

Continuing the tradition of the men's community baseball team first organized by the Fountain Hill Athletic Association, Stevens School developed the sport for younger participants. This 1929 team reflects the limited number of males attending the school at that time. The team competed in the Bethlehem Junior High School League until 1934. (Edward Dreisbach.)

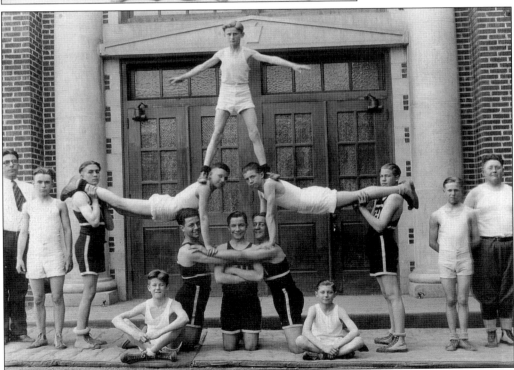

Under the direction of physical education instructor P.E. Ewing (left,) a group of unidentified gymnasts perform a part of their routine in front of the new gymnasium on Seneca Street. Tumbling and balance and strength activities were an important part of Ewing's curriculum for both boys and girls. (Jane Ihle Weddington.)

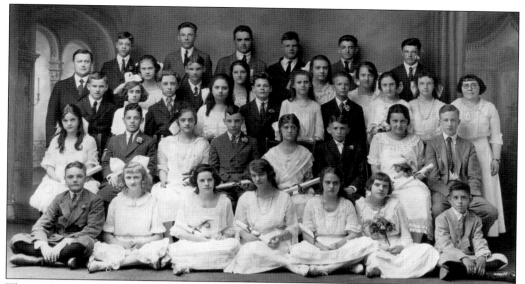

The graduating class of 1921 at Stevens School included Robert McGovern (second row, fourth from the left), who would later serve as the last burgess and first mayor of Fountain Hill. The age for students receiving a diploma this year was between 13 and 15 years. Graduation age was predicated on the curriculum under which students completed their studies. (Robert M. McGovern Jr.)

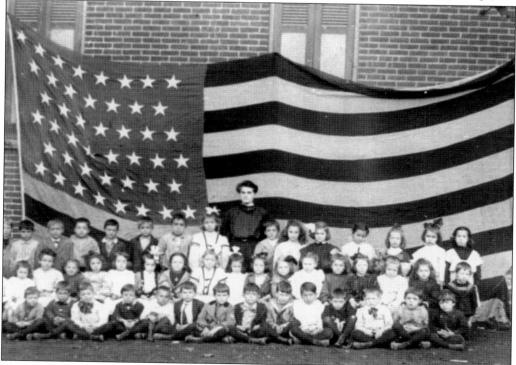

This class of 44 students poses before a 46-star flag at the Stevens School, dating it between 1908 and 1912. The origin of the flag would be a matter of conjecture, since there was no building in the borough capable of flying a banner of the size seen in this image. (Bauman Collection.)

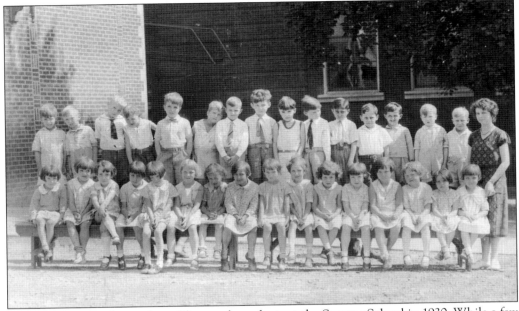

Florence Fritz was the teacher of first-grade students at the Stevens School in 1930. While a few of the students pictured lived on the edges of the borough, most of them were from what was then described as "downtown" Fountain Hill. There was no requirement that borough residents attend Stevens School, and some opted instead for schools in South Bethlehem or Salisbury Township. (Ida May Hagen.)

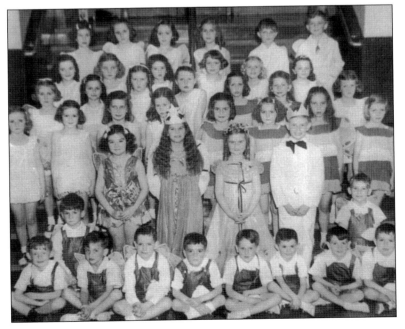

In 1940, the first- and second-grade classes of Stevens School celebrated their spring arts festival by presenting a one-act play titled *The Fairy Queen*. The queen was played by second-grader Eleanor Strelecki. Male members of the class, mostly first-grade students, held "bags of dreams," from which the queen could build her future. (Esther Overdorf Fresoli.)

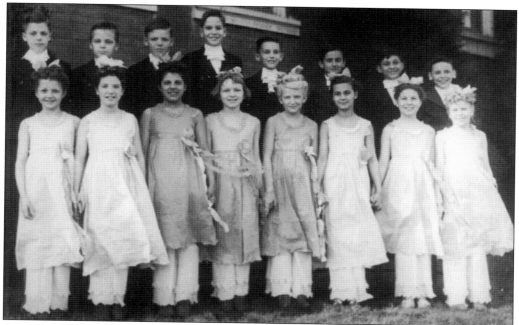

An early spring tradition at the Stevens School was the presentation of musical and dramatic productions from students at various grade levels. In 1945, the junior high school classes joined to offer *The Minuet*. The play was a lighthearted, dance-oriented look at the social decorum that would be expected from proper ladies and gentlemen—no lowlifes allowed. (Pauline D. Holschwander.)

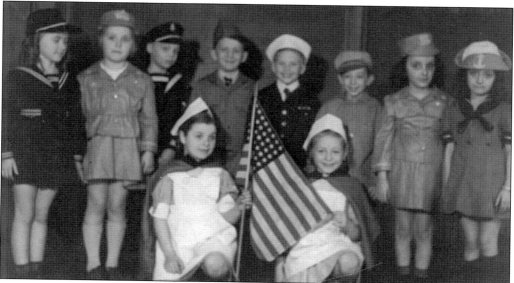

In 1942, the world was engrossed in the struggles of World War II. The attire of this second-grade class shows how deeply the war effort had reached into the schools of the borough. To support the war effort, students were encouraged to purchase 10¢ savings stamps, which could be redeemed for a $25 United States War Bond when a sufficient amount had been amassed. (Jane Ihle Weddington.)

Construction of Fountain Hill High School on its Church Street site began in 1936. It was funded by a Works Progress Administration (WPA) grant of $90,080 and an $110,000 bond issue by the school board. Clerk of the works Stanley Ruth is seen at right advising site supervisors. Dr. Wray H. Congdon of Lehigh University gave the address at the first commencement, in 1937. (Nancy J. Ruth Overdorf.)

The first students entered this 40-room school in September 1937. A formal dedication was held on December 9, 1937. While landscaping, consisting of Hall's honeysuckles, Japanese barberry, and various spruce and hemlock trees, was completed, interior work on lockers and the cafeteria continued as classes commenced. (Susan Reppert.)

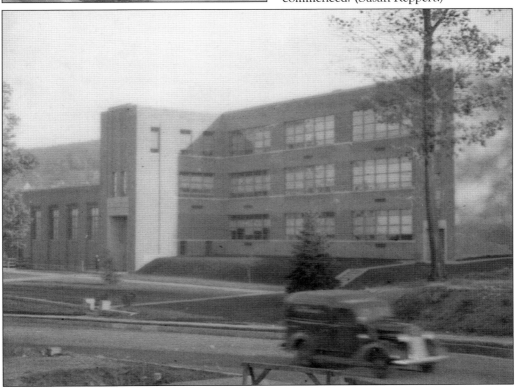

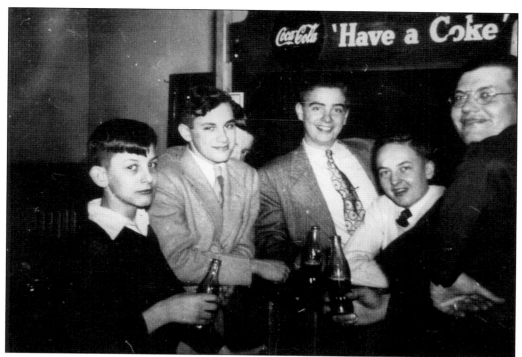

In the early 1950s, the high school and the borough joined to provide an outlet for youthful exuberance by developing a HI-Y program in concert with the Bethlehem YMCA. The Wilson School building, idle at this time, was adapted as a youth center. Activities were supervised by teachers and community members. (John Bauman.)

Student excellence at the high school was the result of a dedicated and academically talented faculty. Many went beyond providing classroom rigor by participating in extracurricular and community activities. This group, seen with their partners at a senior prom at Hotel Bethlehem, included, from left to right, (second row) Earl Bauman, Charles Gehring, Paul Miller, Elmer Green, the unidentified escort of teacher Eleanor Landis (note corsage), Paul Larash, Charles Dubbs, Theodore Brown, and Carl Laubenstein. (John Bauman.)

Robert McGovern Jr. presides at a meeting of the student council at Fountain Hill High School in 1956, one of numerous leadership and advisory groups that were an integral part of the learning environment. While most students are obviously dressed for school picture day, Richard Kosman, a premier basketball player and class iconoclast, stands out in his white T-shirt. (John Bauman.)

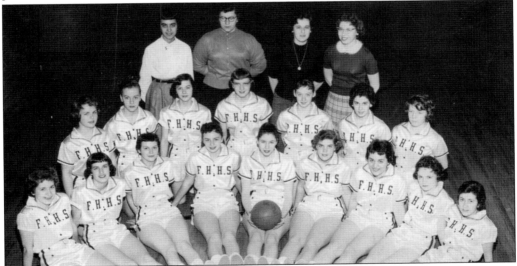

While the boys' basketball team drew most of the attention in the late 1950s, the girls were not to be denied. Competing in the Lehigh-Northampton League, the 1956 girls' team held their own under the coaching of Pauline Jagnasak. The girls were still playing under rules quite different from those used for boys. (Nancy J. Ruth Overdorf.)

50

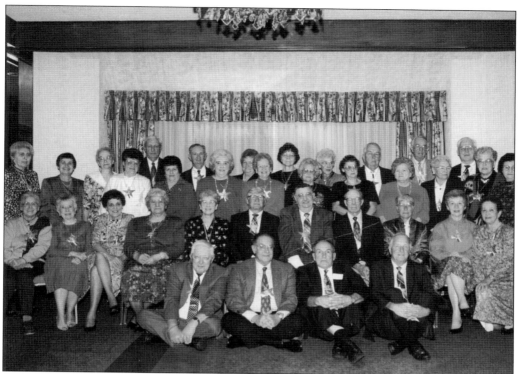

The Fountain Hill High School class of 1942 celebrated its 50th reunion in 1992. Seated in the center of the attending members is Charles Dubbs, who returned to his alma mater to serve as the basketball coach of teams that garnered many honors, including two consecutive class B state championships. (David Hassler.)

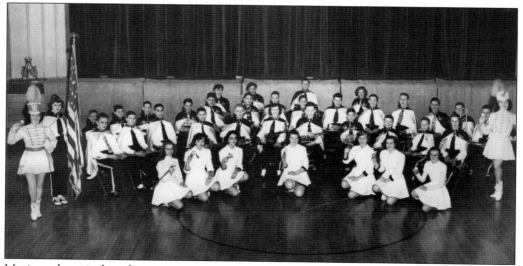

Music and musical performance was an important part of the community from its outset. The 1952 band, led by head majorettes Nancy Mackes and Kathleen Redding, was comprised of more than 10 percent of the student body. Under faculty advisor Harry Buss, it was both a marching band and concert troupe. (Nancy Mackes.)

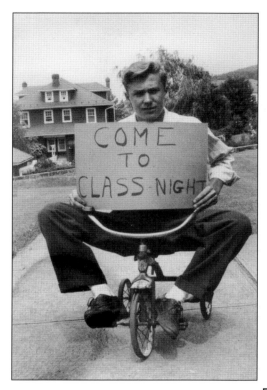

The high school provided many opportunities for students to display their talents and for residents to revel in their exploits. Advertising for the shows was limited, so it was not unexpected to see Alvin Knabel, a creative member of the class of 1946, take to the streets on a tricycle for a bit of whimsical communication. (Lois Brunner Bastian.)

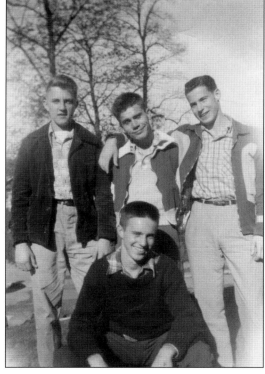

Fountain Hill High School never organized a track and field squad. Despite this, in 1950, Richard Irelan, kneeling in the foreground with three friends, managed to win both the 100-yard and 200-yard dashes in the class B state championship at State College, Pennsylvania, in 1950. Irelan's practice was carried out on the paved surface of Church Street in front of the high school. (Carmella Phieff.)

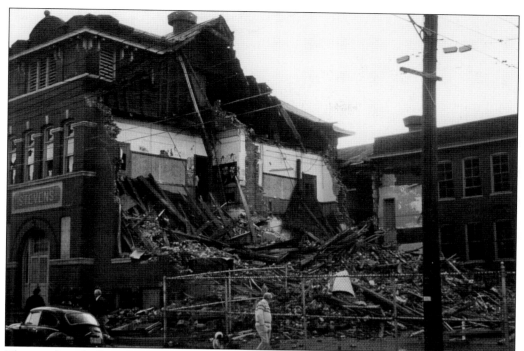

The wrecking ball marks the demise of the Stevens School building in October 1973. Made dispensable by a jointure with the Bethlehem Area School District, its elementary school programs were transferred to the newly renovated former Fountain Hill High School building on Church Street. The cost of renovating the building as a model "open concept" school was $1,591,259. (Jack Ferry.)

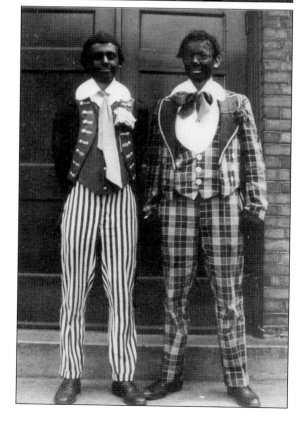

Across the borough during the 1940s and 1950s, minstrel performances were common fundraisers for social organizations and churches alike. In what was a spoof of these community performances, it was not unexpected to find the genre built into the high school's junior-senior day activities, as indicated by the unnamed performers seen here. (Lois Brunner Bastian.)

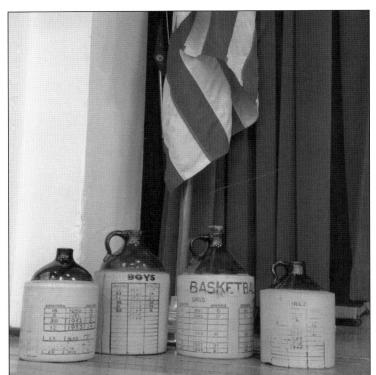

The Little Brown Jugs were contested in boys' and girls' basketball games as a part of the junior- senior day tradition that began in 1942. With some fanfare and chest thumping, the winning class would inscribe the scores on the jugs, which were displayed in the trophy case in the front lobby of the school. (Gavin Strelecki.)

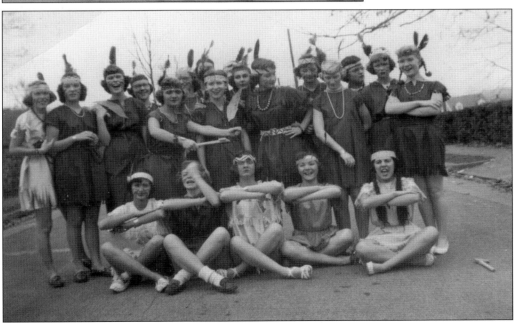

The tradition of a junior-senior day rivalry began in 1941. The day included an afternoon of skits in the school gymnasium followed by boys' and girls' basketball games. The class of 1951 adopted a Native American theme. The girls of the class are preparing for their skit by massing on Greene Court. (Jean Gross Reinert.)

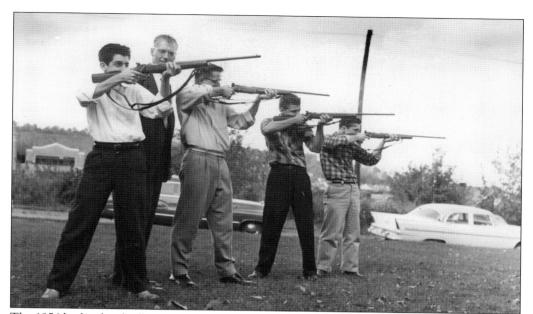

The 1956 high school rifle team, under the supervision of Earl Bauman, included Ted Pellegatta, Alex Kubat, Frank Ballek, and Clint Ballek. They held their practices outdoors on a parking lot behind the school and on a target range in the gymnasium. The team had its origins in 1953 as a club activity under the guidance of John Yoder. (John Bauman.)

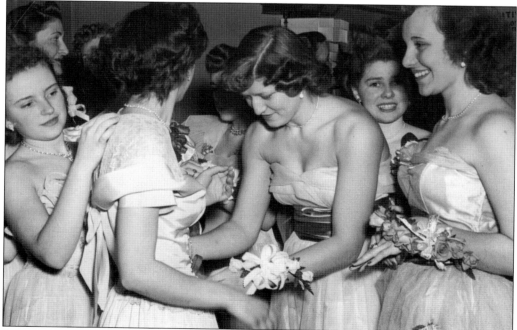

Prom night at Fountain Hill High School was often celebrated at the ballroom of Hotel Bethlehem. The dance was usually preceded by a dinner date at Pellegata's Vineyard Restaurant on Fiot Street. Here, Ursula Bernstein assists with final touches on the attire of her classmates. (Robert M. McGovern Jr.)

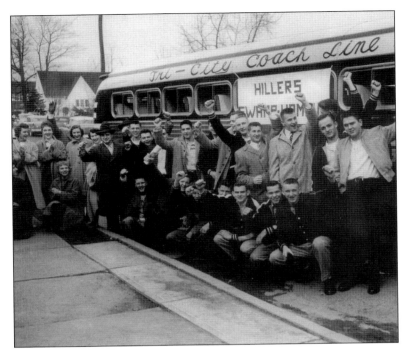

The 1955 basketball team embarks on the long trip to Western Pennsylvania to play Wampum High School in the PIAA class B state championship. The Hillers came up short in their first attempt at a state title, losing 73-61. Jerry Berger led the Hill's scoring with 29 points. (Jerry Berger.)

A group of Hiller basketball supporters prepares to board buses for a trip to the state championship, to be played at the University of Pittsburgh in 1955. It was not unusual for half of the school body and an equal number of borough residents to travel with the team whenever space was thought to be available in a venue. (Jerry Berger.)

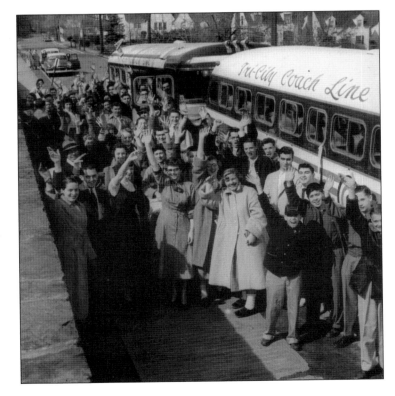

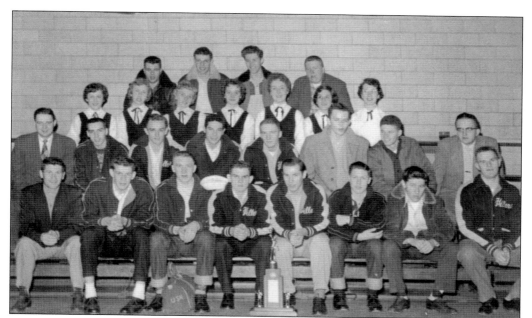

The 1955 PIAA state championship runner-up team poses after returning from the school's first class B championship game. Coaches Charles Dubbs and Paul Miller are at the left. Immediately behind the trophy are team leaders Jerry Berger and Edward Dreisbach. Of the 13 team members, only four were members of the senior class. (Fountain Hill.)

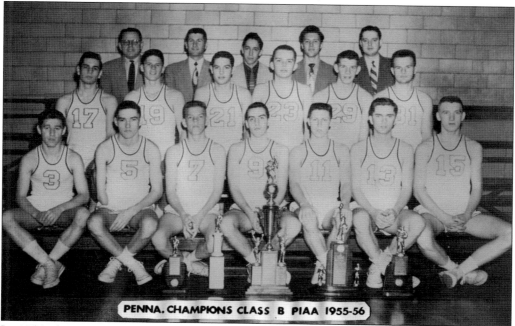

PENNA. CHAMPIONS CLASS B PIAA 1955-56

In 1956, this team captured the first of Fountain Hill's two consecutive class B basketball championships, defeating East Pittsburgh by a score of 63-53. They recorded 30 straight wins after an opening-game loss to Easton High School. In 1957, the Hillers defeated Shannock Valley for their second championship. (David Overdorf.)

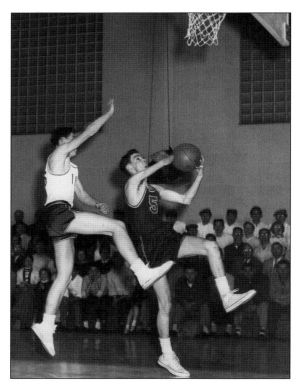

Austin Cyphers streaks for a layup in a Lehigh-Northampton League game at the always crowded Fountain Hill High School gymnasium. In February 1957, Cyphers was featured in the national *Today* weekly newspaper supplement. Born with a handicap, he asked no quarter, participated in many sports, and was active in many community events. (Kevin Cyphers.)

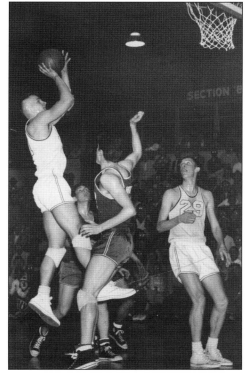

Dale Huseman rises to score on a short jump shot during the 1956 state championship game against East Pittsburgh High School. Karol Strelecki (29), the author of this book, waits for a rebound that never came. Huseman was one of three seniors, including Donald Benner and Frank Monek, who were key players on the championship team. (Donald Benner.)

Fifty years after winning the 1956 class B state championship, basketball team members are honored at the Volunteers in Service to America Basketball Tipoff Dinner at Moravian College in September 2006. Two-time all-state player Richard Kosman is missing. The speaker at center is ESPN sports commentator Bob Ryan. (Donald Benner.)

The District 11 PIAA champions from 1964 celebrate their victory over Pine Grove High School in the championship game. This would be the last basketball championship team at the high school. Faculty members Mario Donnangelo, William Partridge, and coach Charles Dubbs are on the left. At the right rear is high school principal John Spirk. (Ken Weid.)

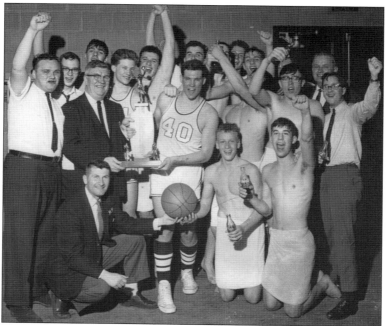

Good times, memorable events, and quirky characters were the order of the evening at a celebration to which all students who attended Fountain Hill High School, as well as the teachers who instructed them, were invited. Held in 2006, the event, at Lehigh University's Stabler Center, drew a crowd of more than 550, including attendees from 23 states. (Esther Overdorf Fresoli.)

The class of 1966, with 37 members, was the last to graduate from Fountain Hill High School. Principal John F. Spirk led the school in this terminal year. From 1936 to 1966, a total of 1,805 students graduated from the school. After 1966, borough students attended Liberty High School in Bethlehem. (John Bauman.)

Four

OUR PLACES

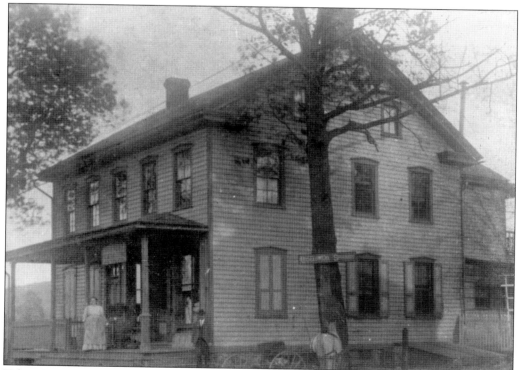

Tobias Weaver's store, at the foot of Lechauweki Avenue, was initially a Salisbury Township business. In addition to serving West Fountain Hill, it provided provisions for guests at the Lechauweki Springs resort who inhabited the John Smiley cottages or built their own cottages on land provided by Smiley within the confines of his holdings. (Bauman Collection.)

The Fountain Hill Cemetery was located on seven acres of ground purchased from Tinsley Jeter. It was dedicated on July 7, 1872, as a "public enterprise." Lutheran, Moravian, Reformed, and other minsters participated. The first interment was in August of that year. Lucy McGovern is seen here at one of the gazebos provided for respite and mourning. (Robert M. McGovern Jr.)

Fred and Martha Schremple, for whom the house at 503 Norway Place was constructed as part of the Norway Place suburb development, are seen here with friends before leaving for an afternoon cruise in their Ford Turtleneck roadster. While main roads were roughly paved, ventures into parts of lower Lehigh County required some care and considerable driving skill. (David Leidig.)

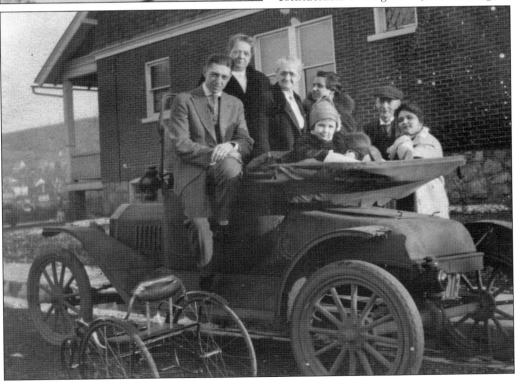

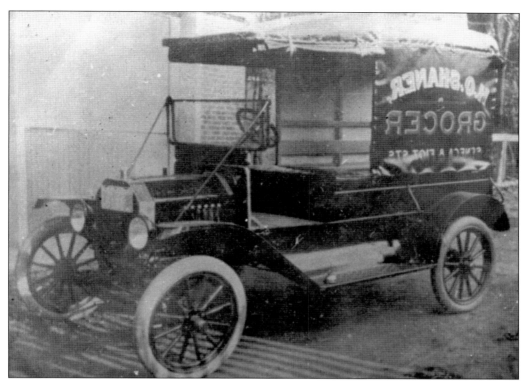

This reverse image shows the delivery truck for the H.O. Shaner grocery store, located on the northeast corner of Seneca and Hoffert Streets. Shaner's was the first grocery in the borough to offer delivery services. As an astute merchant, Shaner raised his profile by supporting the Fountain Hill Athletic Society. (Bauman Collection.)

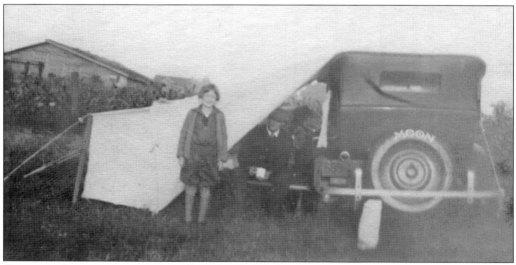

Operating from a site at 1303 Broadway, between Bitting's Hotel and Corina's Grocery, Ed Leidig offered the ultimate in 1920-era touring cars: the Moon. The 1923 Model 6-40 seen here could be purchased with an attachment to provide tent coverage for those who favored camping on the open road. (Ronald Wachter.)

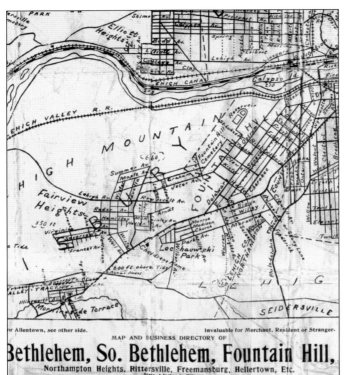

The 1907 directory of cities and towns in the Lehigh Valley included this map of Fountain Hill. In 1920, shortly after the annexation of land from Salisbury Township, a resolution was passed by the borough council that began the process of renaming streets. Among other changes, Wilbur Avenue became Lechauweki Avenue and Monroe Avenue was designated as Souix Street. (BAPL.)

The veterinary practice of H. Leidy Bachman was located on Cherokee Street east of Bishopthorpe Street. The still-uncovered Fountain Valley Creek flows through the center of this image. The house seen at the right in this 1920 exposure was the rectory for St. Ursula's Catholic Church. More recently, it served as the Downing Funeral Home and as an outlet for Coaches Flowers. (Donald Cerrato.)

This Federal-style house at 1105 Delaware Avenue was built in 1871. Home to Charles W. Anthony and his wife, Emily, a member of the Linderman family, it echoes the golf course clubhouse at Lynn Street. Later, it was purveyed into the hands of Edward Leidig, who, in addition to managing his car dealerships in Fountain Hill, became the president of the Lehigh County Agricultural Society. (David Leidig.)

In 1904, a golf course was created by G.B. Linderman on the western edge of the fledgling village. The nine-hole layout stretched from Lynn Street to Hoffert Street between Delaware Avenue and Jeter Avenue. Its clubhouse still stands at the corner of Lynn Street and Delaware Avenue. Fountain Valley Creek coursed along the southern edge of the links. (David Leidig.)

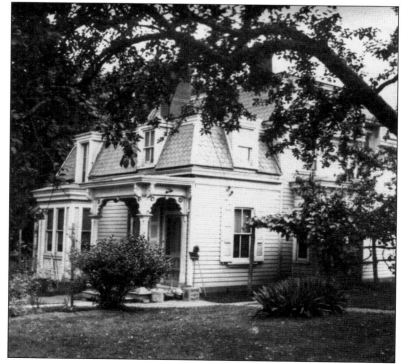

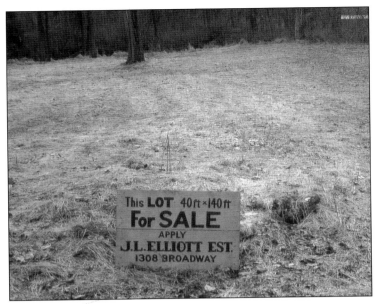

The Norway Place suburb was the brainchild of land developer James L. Elliot, who not only sold land for the development, but was also active in the construction of the homes built there. Elliott also promoted a development on the west end of Bethlehem. While some of the architecture is similar, the Elliot Heights project was not as elegant as Norway Place. (Mary Theresa Taglang.)

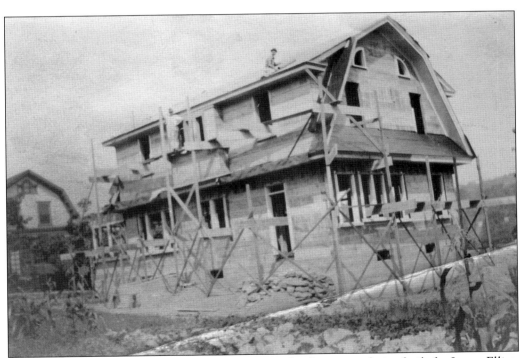

Under construction in 1928 at 1398 Souix Street, this house was being built for Laura Elliot, daughter of burgess and land developer James Elliott, after her marriage to Robert Miller. With its gambrel roof, it was one of two Scandinavian models that were most popular in the Norway Place development. (Mary Theresa Taglang.)

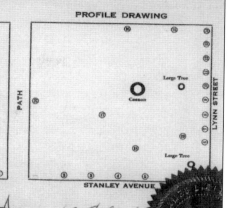

A Memorial

To Whom It May Concern

This is to Certify That on Arbor Day, April ___26th___ 1928, there was held on the Fountain Hill Playgrounds appropriate Arbor Day Exercises in which the Borough School Children participated and that on that day and year a tree was planted on the Playgrounds and dedicated to the memory of

William Reppert

said tree being identified as No. ___6___ on the Profile Drawing hereon.

Burgess *James L Elliot*

PROFILE DRAWING

PATH

LYNN STREET

Large Tree

Cannon

Large Tree

STANLEY AVENUE

In 1928, the Parks and Playgrounds Committee engaged in fundraising activities to finance improvements at the Stanley Avenue playground. One of these was to offer an opportunity for parents to purchase memorial trees to be planted in honor of their children. The children received a certificate designating the site of the tree planted for them. The tree planted for William Reppert still stands on Lynn Street. (Susan Reppert.)

The fountain at the Stanley Avenue playground was dedicated in 1930 to Catherine de Saulles, whose husband, Arthur Brice de Saulles, served as president of the borough council in 1908. Their son John became an All-American quarterback while attending Yale University. The fountain bears the inscription, "A merciful man is merciful to his beast." (Bauman Collection.)

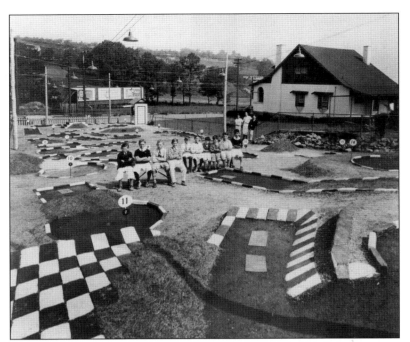

Many have heard stories of the regulation, nine-hole Linderman Golf Course on Delaware Avenue early in the 20th century, but few are aware that a miniature golf course, replete with lights for evening play, existed during the 1930s on the south side of Broadway between Smiley and Lechauweki Avenues. (Mary Jane Miller Scholl.)

While St. Luke's Hospital was the primary center for medical care in the 1920s, it was not the only hospital in Fountain Hill. As attested to by this bill for services, the James Private Hospital, located on Seneca Street between Fiot and Mohican Streets, also provided medical care to a select clientele. The building in which it was located still stands on Seneca Street. (Lois Brunner Bastian.)

An outgrowth of concern by members of the Cathedral Church of the Nativity, Bethlehem's first hospital was established in 1873 on Broadway, then called Carpenter Street, near the Five Points. The hospital was opened on St. Luke's Day in a renovated 20-room brick house as a trauma center to treat injuries from railroad and mining accidents. (SLUHN.)

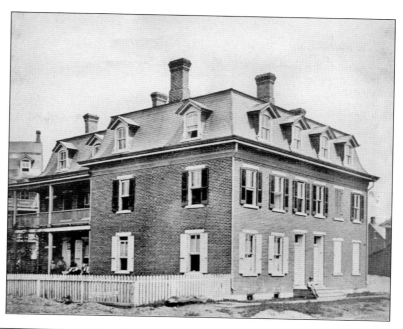

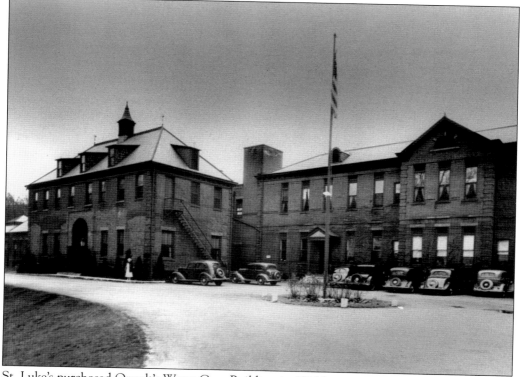

St. Luke's purchased Oppelt's Water Cure Building in 1875 but soon outgrew it. The new front entrance of the hospital reflected a rapid expansion of buildings and services at the turn of the 20th century. Plans created in 1879 included the construction of four one-story pavilions to supplement the space in the administration building and provide expanded services. (SLUHN.)

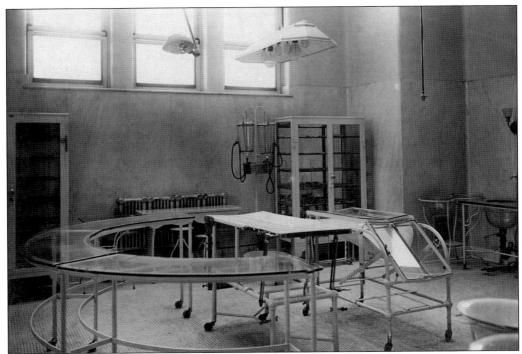

Of the four original pavilions from the 1879 plan, only three—operating, men's, and kitchen—were completed at this time. Under the direction of Dr. W.L. Estes, a skilled surgeon, the hospital expanded to provide specialized care for pathology, obstetrics, contagious diseases, and operations. The Rebecca Thomas Memorial Operating Pavilion was erected in 1901. It featured a glass operating table that was considered state of the art. (SLUHN.)

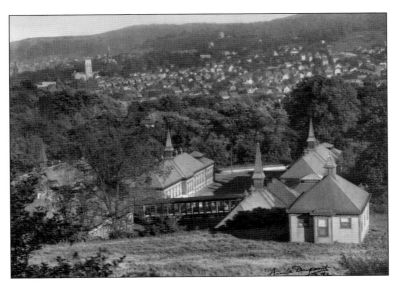

Viewed from the park atop Ostrum's Ridge in 1926, the multiple medical pavilions and support buildings of St. Luke's Hospital speak to its rapid expansion in meeting the needs of a growing Lehigh Valley community. At the same time, the wooded areas south of the hospital suggest that Fountain Hill itself was still not heavily developed. (SLUHN.)

Born and raised in Fountain Hill, Dr. William Downing Reppert served his medical internship at St. Luke's Hospital after graduating from the Temple University School of Medicine. From 1975 to 1991, he was chief of staff at the hospital while maintaining a private practice at 1059 Seneca Street, next to his father's pharmacy. (Cynthia Reppert.)

While the curriculum of the St. Luke's Hospital School of Nursing was rigorous and expectations were high, not all was work for student nurses in the long-running and highly acclaimed program. This group of soon-to-be-graduated members of the class of 1981 takes a break from their classroom and practicum requirements. (Nancy J. Ruth Overdorf.)

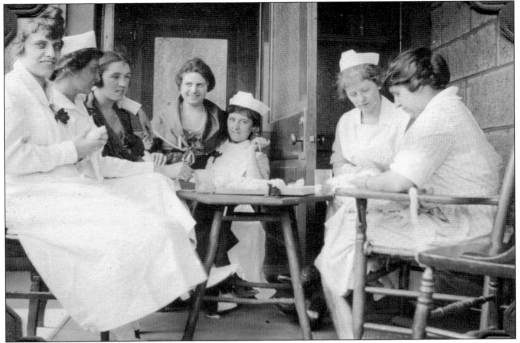

St. Luke's has never underestimated the value of a broadly supportive environment in dealing with illness and trauma. A family visit at St. Luke's Hospital in the 1920s was sometimes a relaxing interlude between patients, relatives, and staff. The Fountain Hill family seen here appreciated the recuperative value of fresh air and good conversation. (David Leidig.)

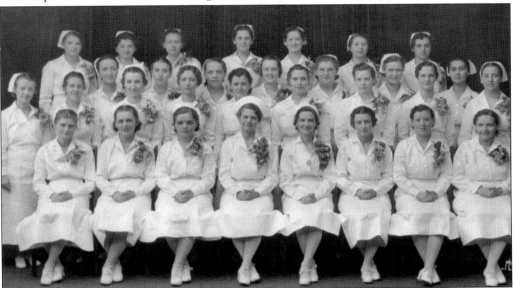

To keep pace with the best in medical practice, the St. Luke's Hospital Training School for Nurses was created in December 1884. It was the fourth such institution in the United States. In 1935, the graduation class pictured here celebrated the 50th anniversary of the founding of the school. (Robert M. McGovern Jr.)

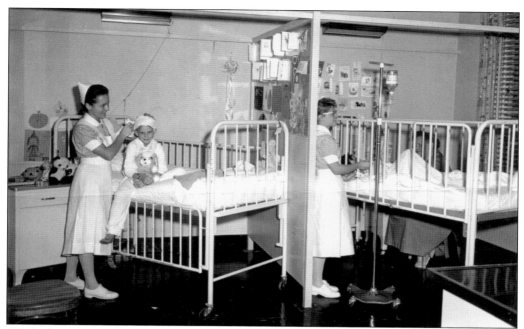

While the reputation of the school of nursing at St. Luke's drew applicants from far beyond the bounds of the Lehigh Valley, high-quality local high school graduates often chose to stay in Fountain Hill to pursue their dreams. Barbara Huhn Rundle (left) and Karen Tereska Drake (right), seen here providing care in the pediatric ward in 1962, are exemplary of such decisions. (Karen Tereska Drake.)

After the death of Augustus Fiot in 1868, his Fontainebleau mansion was purchased by Tinsley Jeter, who, with the aid of other leading citizens, created the Bishopthorpe School for Girls on the site. It remained such until 1931, when it was conveyed to St. Luke's Hospital for use as a residence for the institution's Training School for Nurses. Despite protests, it was razed in 1994. (Pauline D. Holschwander.)

Having been orphaned himself, William W. Thurston, the president of Bethlehem Iron Company from 1888 to 1890, was moved by the plight of children whose parents died during a smallpox epidemic in 1881. In 1882, he rented a house on Cherokee Street and created a children's shelter, which he supported with his own resources. The Thurston Home for Children was incorporated as the Children's Home of South Bethlehem in 1886. (Kidspeace.)

The Annie Lewis Wiley Memorial Children's Home was constructed and opened in 1885. Designed by prominent architect Andrew W. Leh, its spacious quarters provided a nurturing environment for as many as 40 children between the ages of two and fourteen at its opening. The site became popularly known as Wiley House and was informally adopted as a part of Fountain Hill. (Kidspeace.)

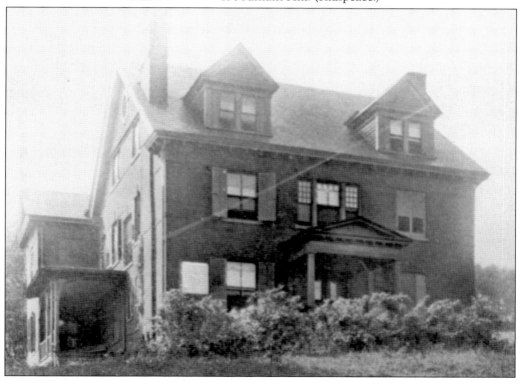

Capt. James Wiley, a Marine officer and philanthropist, provided a gift of $6,000 in 1895, with which the board of directors of the children's home was able to purchase a six-acre plot of land in Salisbury Township to create a new site for the institution. Captain Wiley also made a bequest of $5,000 to St. Luke's Hospital, the Annie Lewis Wiley Memorial Fund, for hospital maintenance. (Kidspeace.)

In years before the advent of television and the Internet, residents at Wiley House often gathered in family-like groups before bedtime to be entertained by music, comedy, and drama provided on the radio. Small group excursions to cultural sites and events were also part of the Wiley House experience. (Kidspeace.)

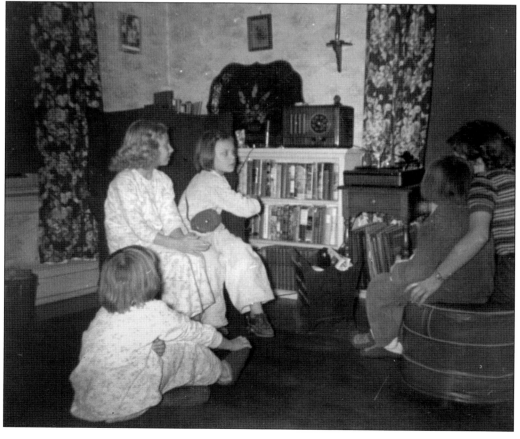

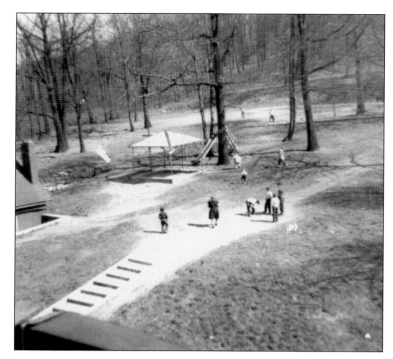

In addition to structured care and education, one of the prime benefits of the Wiley House experience was the availability of open space and fresh air for children who had often come from stifling urban settings. The space seen here was supplemented by an active farm that provided fresh fruit, vegetables, and dairy products for the kitchen. (Kidspeace.)

Journals at Kidspeace indicate that, in its earlier years, the institution was the recipient of a variety of donations from businesses and citizens of South Bethlehem and Fountain Hill. These ranged from fresh food to cash allotments. As a result of this largesse, the children in residence were provided not only with basic sustenance, but also with the amenities available to other children in the borough. (Kidspeace.)

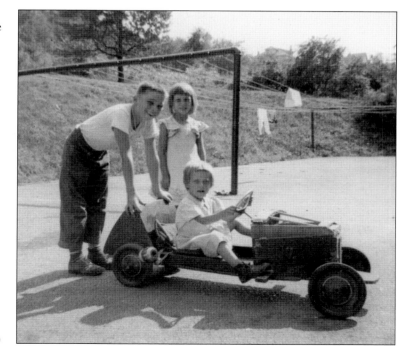

One of the earliest silk mills in the Lehigh Valley, the Lipps & Sutton Mill, on the south side of Seneca Street, was built in three sections between 1886 and 1904. The building was designed by locally prominent architect Andrew W. Leh. The mill also operated under the names Lehigh Valley Silk Mill and the Gallia Silk Mill. It is now listed in the National Register of Historic Places. (Edward Redding.)

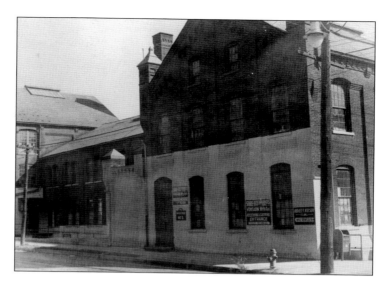

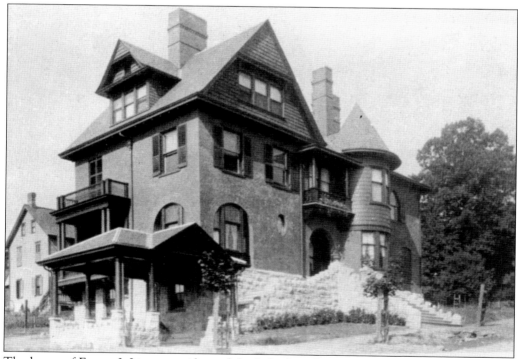

The home of Emory J. Lipps, president of the Lehigh Valley Silk Mill, stood at the southwest corner of Clewell Street and Jeter Avenue. A disastrous fire destroyed the home in 1930. Lipps held a series of patents relating to a more efficient method of spinning textile threads. He also patented a spinning spool that assured the processing of a greater amount of the product. (Bauman Collection.)

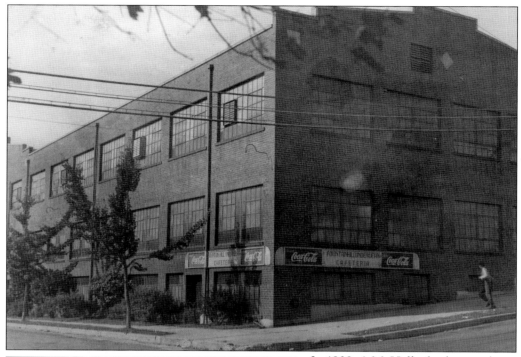

In 1908, A.M. Hollenbach moved his laundry business to a plant at Bishopthorpe and Cherokee Streets. When his business failed, a new consortium, made up of James Beitel, J. Ruskin Jones, and C.H. Edwards, took over and created the Electric Laundry Company, which lasted until 1920. Twentieth Century Silk moved in for several years before the Fountain Hill Underwear Mill replaced it and added a cafeteria. (Edward Redding.)

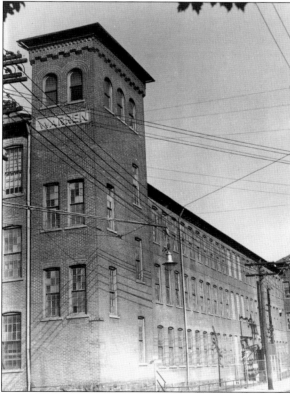

The Warren Silk Mill building, on the north side of Seneca Street at Clewell Street, was erected in 1895. In 1914, the mill employed 200 workers. Its boiler house and coal yards were an intrusion on the residential nature of the borough. The mill ceased operation in the borough in 1937 after declaring bankruptcy. (Bauman Collection.)

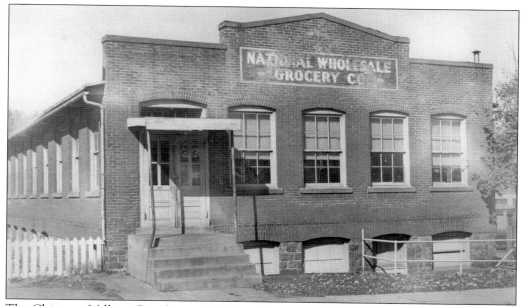

The Chipman Mill, on Broadway at Hellener Street, opened in 1911. It prospered for a time, employing 120 people in 1914, but failed soon after. Succeeding enterprises in silk and fur also failed during the Great Depression. After a vacancy of many years, it was occupied by Abraham Greene's National Wholesale Grocery as a warehouse. It has been vacant again since the 1960s. (Edward Redding.)

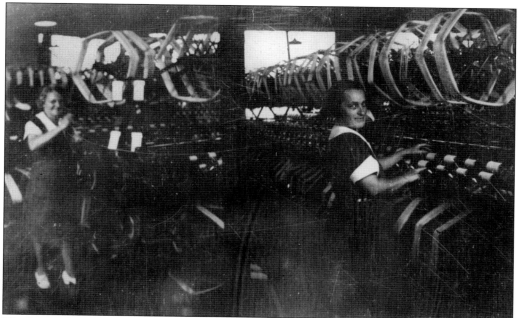

Winders toil in the Lehigh Valley Silk Mill at the beginning of the 20th century. While some men were hired, employees were primarily women from South Bethlehem and Fountain Hill. Pay was meager, tasks were repetitive and sometimes dangerous, and conditions were bleak. The application of Emory Lipps's patents improved output but not the status of the worker. (BAPL.)

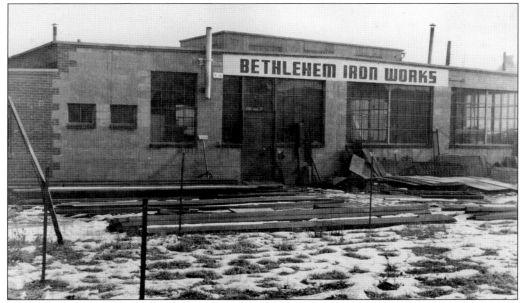

The southwest corner of Cherokee and Bishopthorpe Streets was the site of what some consider a misguided attempt to bring industry to Fountain Hill. In 1910, W.F. Danzer established a machine shop here that, in the judgment of historian Earl J. Bauman, "did not add to the beauty of the borough." In 1936, Andrew Panick and Frederick Dornblatt took over the site to create the Bethlehem Iron Works. (Edward Redding.)

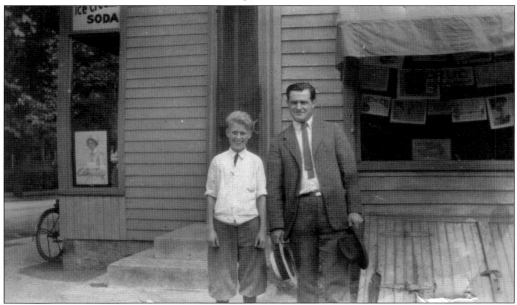

In 1923, Levi Reppert opened the first pharmacy in the borough on the southeast corner of Seneca and Hoffert Streets. He compounded all prescriptions on the premises and dispensed advice freely. As a member of the school board, Reppert led a delegation to Washington, DC, to lobby for WPA funding to build the new high school in 1936. He is seen here with Larry Cuppy. (Cynthia Reppert.)

Laura Reppert, the sister of Levi Reppert, stands at the door of the original pharmacy in the borough of Fountain Hill. The popularity of Reppert's services and his own entrepreneurial spirit dictated that he abandon this small site. In later times, this building housed Newman's Dry Goods & Notions. It also served as a US Post Office substation. (Cynthia Reppert.)

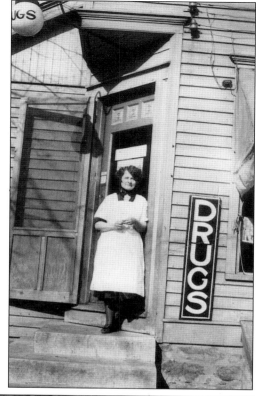

The pharmacy building built by Levi Reppert at 1061 Seneca Street expanded services and offered other amenities to the community. Reppert ran a mail-order sporting goods enterprise in the basement. When Warren Hunsicker took over the store, it remained a staple in the community. The small building at the right of the store housed the offices of William Reppert, MD. (Cynthia Reppert.)

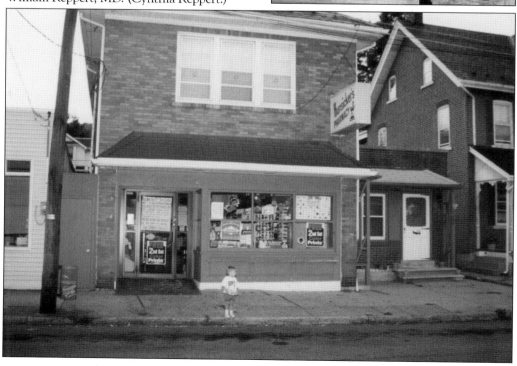

For many years, William Sames was looked to for service and advice at Hunsicker's Pharmacy on Seneca Street. Hunsicker's was the successor to the original Reppert's Drug Store, both of which not only filled prescriptions, but also offered over-the-counter medications, cosmetics, reading materials, and small gifts and notions. Both also featured a soda and dairy counter. (William Sames.)

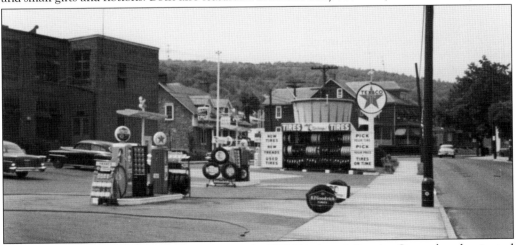

The longest-operating commercial venture on the Hill, Friedman's Service Center has dominated the triangle at Broadway and Itaska Street for over 70 years, with Texaco products and reliable repair services. The site was at the original western boundary of the borough as defined in 1893. The service center was as much an icon as the Dixie Cup, which shared the space for many years. (Friedman family.)

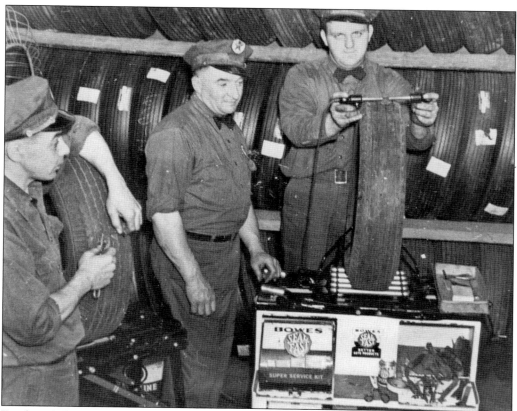

Friedman's Service Center appeared on Broadway in 1936 as Eddie's Texaco. It was noted for tire and tube repair that sealed holes with "Dough Boy Dough" and salvaged punctured tubes using the Bowes Chemical way. Assistant Vincent Bold is on the left with a finished product. Eddie Friedman is in the center watching his brother Joe operate the tire re-groover. (Friedman's Service Center.)

In the southeast corner of the borough, at the end of South Lynn Street, a 1946 DeSoto Custom is parked next to a stone house that was built by noted Bethlehem contractor Benedict Birkel for his mother in 1914. As late as 1957, Wendell Deufel, his mother, and a sister occupied the house, which had no indoor plumbing, no electricity, and no heating other than a single woodstove. (Gavin Strelecki.)

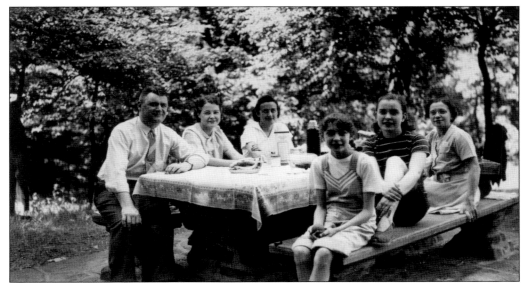

Atop Ostrum's Ridge, at the reservoir behind St. Luke's Hospital, was the "Old Park," accessible from both Fountain Hill and the south bank of the Lehigh River. Here, in the 1930s, two families enjoy a summer picnic. From left to right are (left side) John Rodenbach, Florence Rodenbach, and Ruth Brunner; (right side) Betty Ann, Lois, and Bertha Brunner. (Lois Brunner Bastian.)

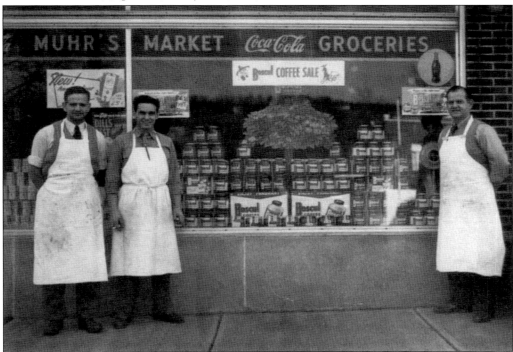

In 1936, Mary and Joseph Muhr expanded their South Bethlehem grocery and meat market business by opening a "modern" store on the corner of Broadway and Smiley Avenue in Fountain Hill. This store was strategically located near the expanding Norway Place suburb. From left to right, their sons Robert, Walter, and John celebrate the opening of the new venue. (Muhr family.)

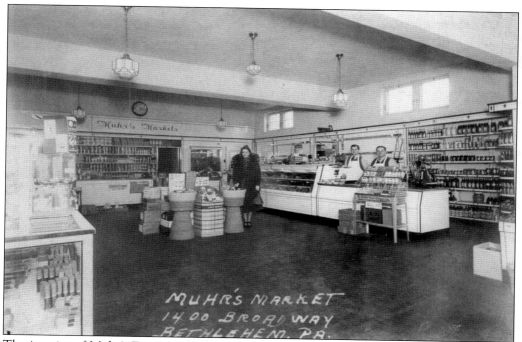

The interior of Muhr's Fountain Hill Meat Market demonstrates the inclusion of significant customer space as well as the latest in product display. Mary, Joseph, and John Muhr welcomed the first Fountain Hill customers to the new store with the motto "Purveyors of fine food for discriminating people." (Muhr family.)

Counted among the 19 grocery stores that dotted the Hill, Mohap's Grocery, on Hoffert Street below Russell Avenue, was one of a few that were located off the Broadway–Seneca Street business corridor. Attached to the Mohap home, the store dispensed a limited inventory of basic food items. Anna Mohap and Frances Zcor often served customers there. (John Mohap.)

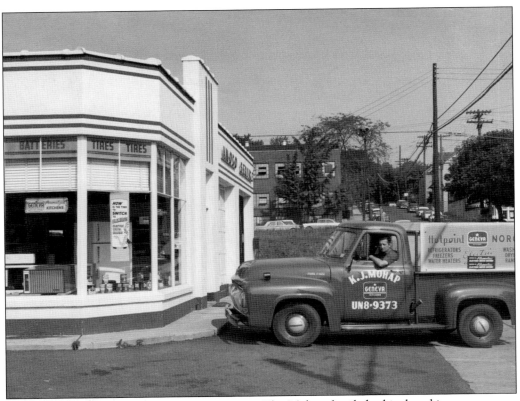

The Mohap family had its hand in many borough businesses. Kalman Mohap operated the service station offering Amoco products and small repairs on Broadway at Bishopthorpe Street. Capitalizing on its location, the family provided home appliance services from their 1952 Ford F100, under the Hotpoint label, to both South Bethlehem and Fountain Hill. (John Mohap.)

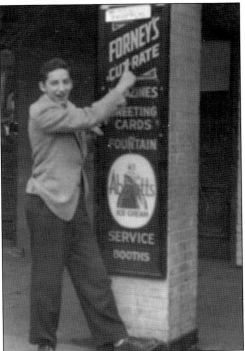

Frank Forney's Cut-Rate was the second pharmacy and confectionery store in Fountain Hill. It operated in the former Grand Central Hotel, which was built in 1874 at 942 Delaware Avenue by brick maker James Benner. Forney was a proponent of patent and over-the-counter medications. Lenny Titner is seen here promoting the opening of the business. (John Spadaccia.)

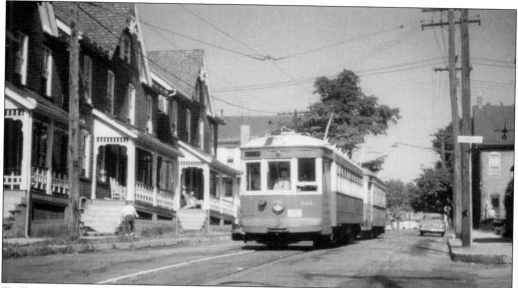

Trolley lines wound strategically through the borough, leaving Broadway for a loop north to Seneca Street and a stop convenient to St. Luke's Hospital. Here, two Lehigh Valley Transit 600 cars descend Fiot Street in 1952. They are in tandem heading toward the scrap yards of the Bethlehem Steel plant as a part of the gradual reduction of stock leading up to the termination of trolley service in the Lehigh Valley in 1953. (Dennis M. Kery.)

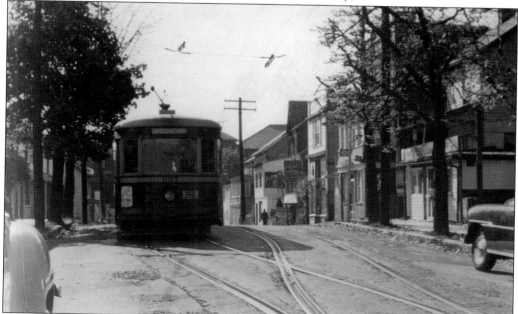

As early as 1898, agreements were made with the Allentown & Lehigh Valley Traction Company to provide electric car service on a line through Fountain Hill. An electric car of the Lehigh Valley Transit Company is shown here proceeding eastward at the Jack's Place siding on Seneca Street. Jack's Place was a luncheonette popular with trolley personnel and silk mill employees. (Susan Reppert.)

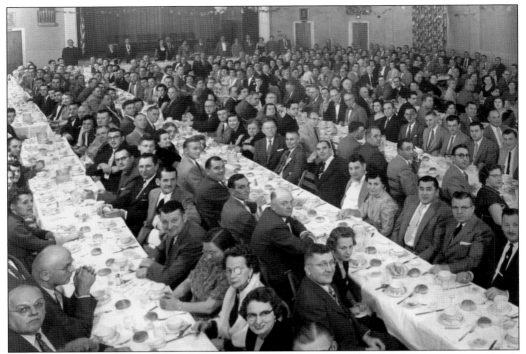

The Fountain Hill Beneficial Society had its origins, like so many other local institutions, in South Bethlehem, where it was founded as the Deutscher Maennerverein in 1916. Moving to Fountain Hill in 1924, it was first identified as the German Club but later chartered as the Fountain Hill Beneficial Society. The society's building was a prime location for a large variety of borough meetings and celebrations. (Robert M. McGovern Jr.)

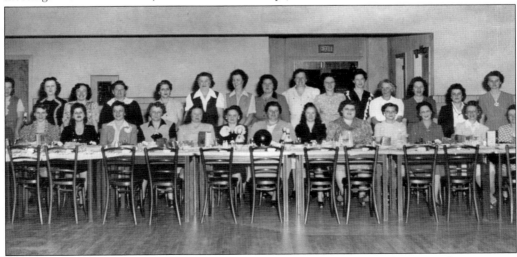

The Fountain Hill Beneficial Society provided opportunities for a wide range of community activities. The addition of bowling lanes to the building led to the creation of the Women's Bowling League. The 1944–1945 participants are seated here in the main hall of the building after their annual banquet. During World War II, the society allowed residents to use unimproved land on its east to plant victory gardens. (Fountain Hill.)

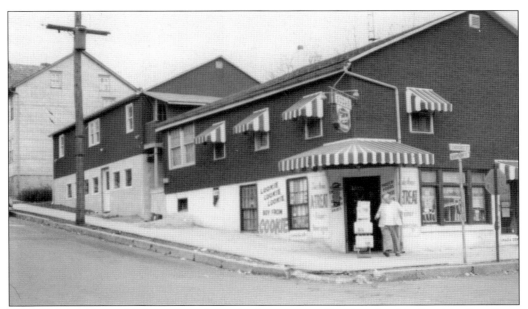

Clarence Cook's establishment, with its rhythmic motto "Lookie, Lookie, Lookie, Buy From Cookie," filled the corner of Cherokee and Bishopthorpe Streets. Sometimes a grocery, sometimes a confectionery, always a marvel with a plethora of enticements for young and old, Cookie's had a unique niche in commercial Fountain Hill. (Edward Redding.)

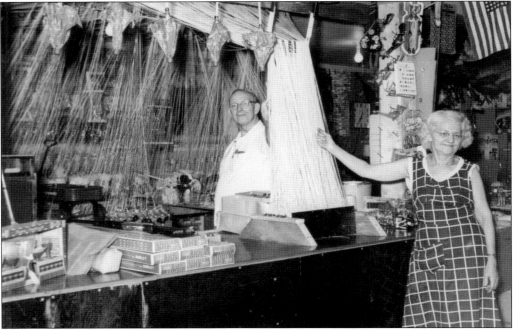

Always looking for a competitive edge, Clarence Cook, seen here with his wife, Georgie, offered a string-pull game that promised a prize at the end of every string for only 10¢ a chance. The game was modeled after a similar enterprise that ran during the summer at Dorney Park in Allentown. (Edward Redding.)

"The Home of the Future," at 736 Delaware Avenue, was built in 1935 with the support of the *Bethlehem Globe-Times*. It was appointed with the latest in home comfort: heated by an automatically stoked coal furnace and cooled by a Carrier Air Conditioning System. The rear featured a tennis court and patio. The driveway contained an embedded heating element to ease access in winter weather. (Raymond Metzgar.)

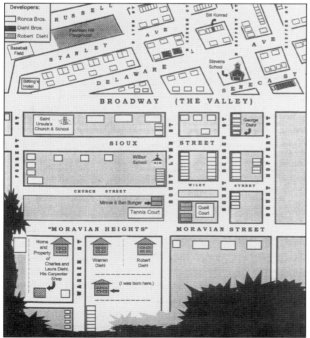

In an unpublished memoir, Irene Diehl Konrad included diagrams of the borough as she observed it in 1920 and 1936. This 1936 illustration shows features like quoit and tennis courts that no longer exist. In addition, she identifies houses built by various contractors, including her grandfather Charles Diehl. Talking of the borough's main street in 1920, Konrad said that "whoever called it Broadway had a sense of humor." (Judith Bloch.)

90

Austin Cyphers strokes a shot on the tennis court at the St. Luke's Hospital School of Nursing on Ostrum Street. In earlier years, the sport was so popular that public courts were also available next to the Municipal Building on Clewell Street and on Moravia Street at Lynn Street. In addition, several private courts graced the borough. (Kevin Cyphers.)

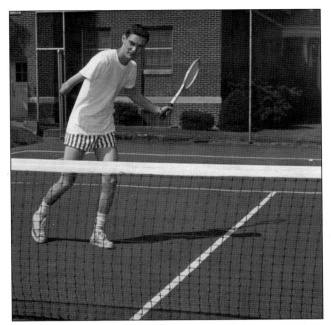

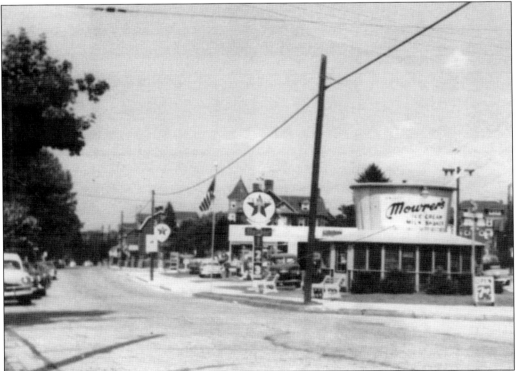

Mowrer's Dixie Cup was a favorite stop for a cool ice cream treat on a hot summer day. Constructed from material produced at Bethlehem Steel, the Fountain Hill site was one of four "Cups" dotting the Lehigh Valley. In addition to the namesake owners, the cup was owned and managed by various borough families, including the Friedmans, Taglangs, and Mohaps. (Friedman family.)

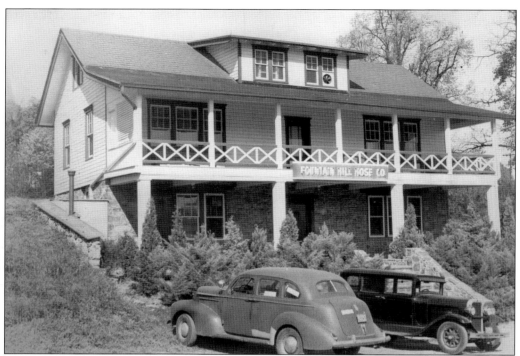

Having operated in a clubhouse on Moravia Street and in the Wilbur School building, the Fountain Hill Athletic Association, which organized community athletic activities, including baseball, basketball, and pass football, built this structure at the west end of Russell Avenue in 1924. After the demise of the athletic association, the property was conveyed to Fountain Hill Hose Company No. 1. (Edward Redding.)

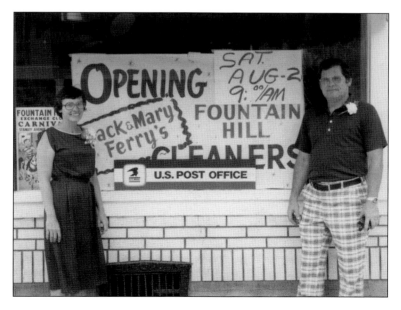

The store owned by Tobias Landis at 1101 Seneca Street was a haunt for workers at the nearby silk mills as well as a grocery outlet for local residents. When Landis died, the business was taken over by Joseph Salabsky. With the demise of the mills, the building was vacant until Jack and Mary Ferry reopened it as a dry cleaner, notions purveyor, and US Post Office substation. (Jack Ferry.)

After the razing of the Stevens School building on Seneca Street, construction of the high-rise Clarence C. Aungst Home for Senior Citizens was begun in 1981, and it was ready for occupation in September 1982. Clarence Aungst was the founding chairman of the Lehigh County Housing Authority, on which he served for 23 years. (Jack Ferry.)

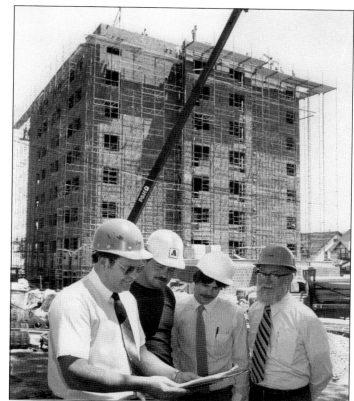

Looking across the borough in 1943, the still almost new high school, as well as St. Ursula's Catholic Church, dominate the center of the town. The clusters of row homes in this snowy scene indicate that Tinsley Jeter's vision of a pleasant suburb was coming to fruition. One can still see, to the left of the school and behind the church, a considerable amount of undeveloped former farmland. (David Strelecki.)

The clashing wooden sticks of box hockey might be considered a liability risk today, but in the 1940s and 1950s, the matches were high sport at the Fountain Hill playground for children of all ages. Sticks had to be replaced periodically during the summer. So battered became the original wooden boxes that the concrete versions in this picture were put into place. (Pauline Moser.)

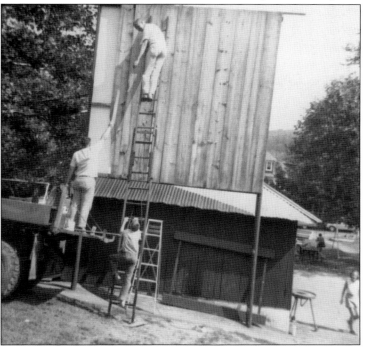

Monday Night at the Movies was long a cherished event at the playground. Crowds would be seated on the high bank on North Lynn Street to enjoy films like *Benji*, *Robin Hood*, and *Sergeant Swell*. At season's end, the tall screen would be boarded up, usually by Ed Redding, seen here on the ladder, and borough employees. (Pauline Moser.)

Viewed from Russell Avenue near the Fountain Hill Hose Company, the borough playground is seen here in a very formative stage. A paved area with two basketball hoops and a volleyball court has been developed, and a crude softball field is in the foreground. Giant swings donated and installed by Bethlehem Steel are seen to the left. (Edward Redding.)

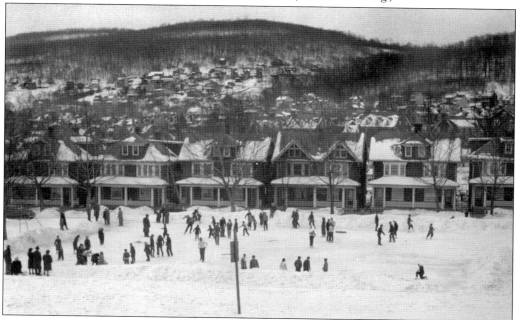

Beginning in 1941, the basketball courts at the playground were flooded by the fire department as soon as weather conditions assured a solid ice surface. Skating, which once required a trip to the Lehigh Canal or an outlying pond, became a popular winter activity. In addition, the borough would block off South Lynn Street to add sledding to the winter menu. (Robert Spirk.)

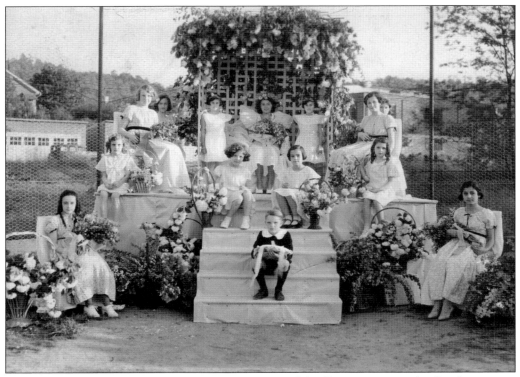

May Day exercises at the Stanley Avenue playground in 1931 involved 670 schoolchildren. The highlight was the crowning of the May queen, Mary Taylor. The event was organized by physical education teacher P.E. Ewing, assisted by the staff of the Stevens School. It was estimated that 1,500 people were in attendance. (Robert Spirk.)

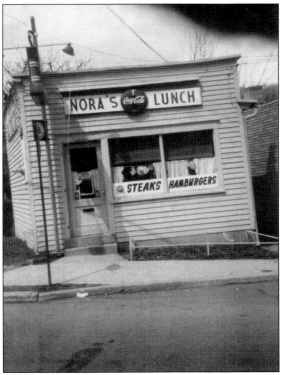

Adjacent to the Tinsley Jeter Triangle and the Elliot siding of the Lehigh Valley Traction Company, Nora's Lunch, operated by Nora Danner, provided a basic fries and sandwich menu in the mid-1900s. Earlier, this building housed Clara Bauer's Hershey Ice Cream Store, where, for a nickel, one could purchase a chocolate-covered popsicle called the Banjo. (Nancy Behum.)

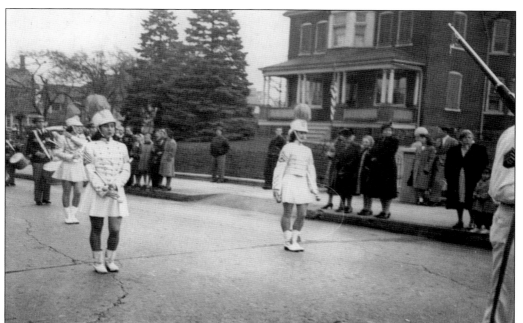

The American Legion Post No. 406 band was a staple in all parades. They are seen here passing the C.F. Hellener farmhouse at the eastern end of the borough on Broadway. The Hellener farm was established in 1852 when various parcels of the larger Hoffert farm were sold off in smaller parcels. (John Spaddacia.)

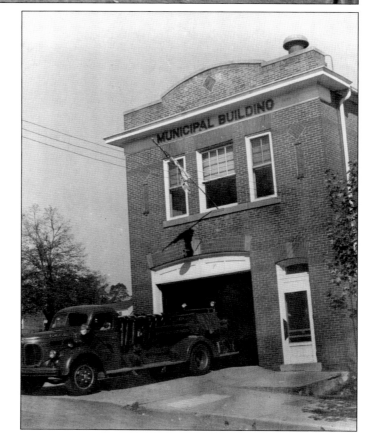

On display here at the Municipal Building on Clewell Street is the fire department's new 1948 Ward pumper. The apparatus included a 200-gallon tank and the ability to pump at 750 gallons per minute, requirements thought necessary by both the department and the borough leadership. (Bauman Collection.)

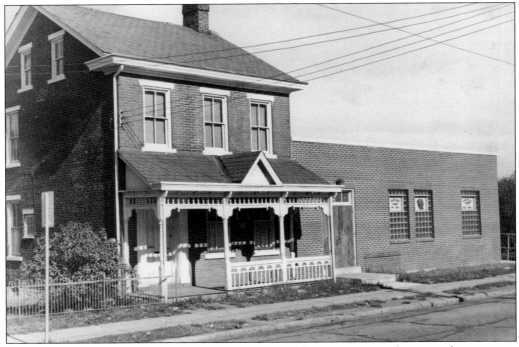

The building at 1137 Broadway was the headquarters of the Improved Order of Red Men. Chartered by Congress, it is the oldest fraternal organization in the United States. The group supported charitable, youth, and educational programs. Their custom of dressing in Native American garb and face paint for parades sometimes put a fright into younger residents. (Edward Redding.)

The opening of a sinkhole on Delaware Avenue near Mohican Street presented a whole new view of the borough. Geologic investigations revealed a massive limestone cavern that stretched from the Delaware venue south to Seneca Street. Branches of the cavern stretched east and west along Seneca Street. (Robert M. McGovern Jr.)

Floyd R.E. Fox and William J. Jones of the Pennsylvania Mineralogical Society and the National Speleological Society explore the 12-foot-high cavern in the limestone at the head of the underground complex. Stalagmites and stalactites, common to caverns that underlie much of the Lehigh and Saucon Valleys, were excavated and examined. Mayor Robert McGovern had one such item cut and polished into a set of bookends. (Robert M. McGovern Jr.)

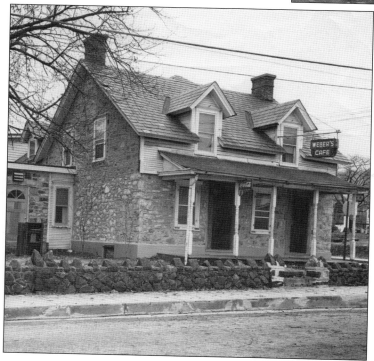

Weber's Café, sometimes recognized by other names since the Weber family ceased ownership, is on the site of one of the earliest structures in the area. The stone house built here by Eugene J. Benner in 1886 was converted to the comfort business late in the 19th century as the East End Hotel. (Barbara Weber Williams.)

Café owners Gus and Betty Weber hold forth at the bar with waitress Kathryn Kutz. The owner's sense of humor is in the sign above the bar: "Our cow died, we don't need your bull." The Webers established their presence in 1950, after the structure had served as Schuster's Hotel and the Chat A-While Inn. (Barbara Weber Williams.)

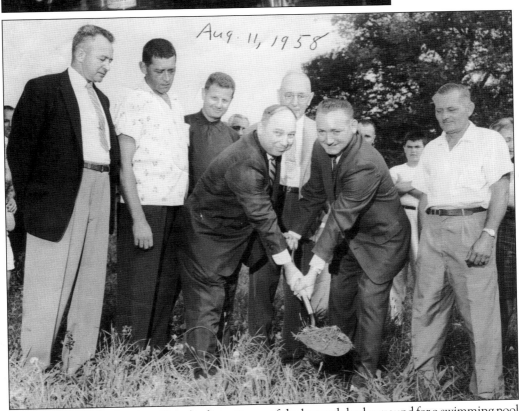

After an intense fundraising effort, leading citizens of the borough broke ground for a swimming pool on Stanley Avenue in 1958. While much of the $30,000 needed was raised from small donations, the Bethlehem Steel Corporation provided a gift of $10,000. Doing the heavy lifting are burgess Robert McGovern and borough council president Thomas Redding. (Thomas Redding.)

Five

OUR FACES

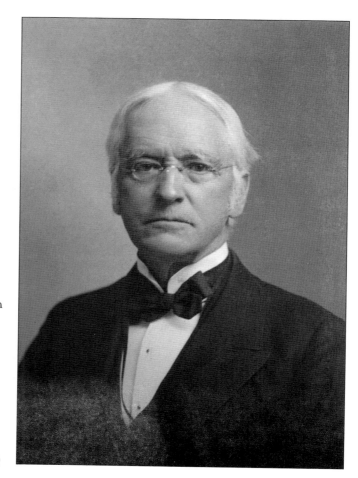

Tinsley Jeter was one of the leading entrepreneurs in South Bethlehem. Having settled into his own estate, which he named Fontainebleau, Jeter envisioned the development of his larger landholdings. He named the area Fountain Hill and declared it "among the most desirable locations for handsome and pleasant dwellings to be found in Pennsylvania." (Fountain Hill.)

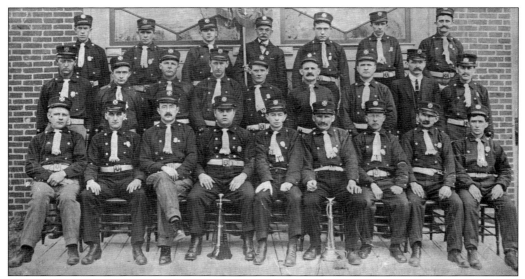

Shortly after incorporation as an independent borough, Fountain Hill created a volunteer fire company to provide for the safety of its residents. The number of volunteers in this 1901 photograph, as well as their dress and demeanor, speaks to a high degree of pride in the developing community. Harold Koch was named the first chief of the department. (Ronald Wachter.)

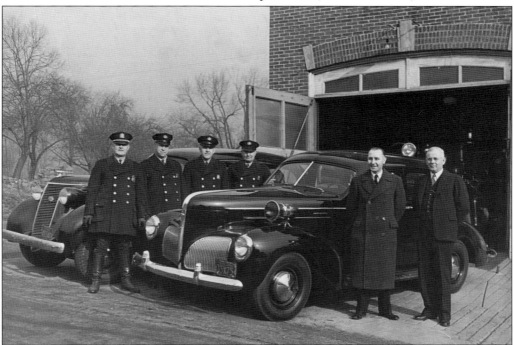

In front of the Municipal Building on North Clewell Street, a new police car, bearing a "Dealer" license plate, is previewed by, from left to right, patrolmen Walter Keeler and Gus Harrison, Chief Victor Kaufman, patrolman Henry Shannon, burgess James Taylor, and Councilman Robert Miller. Headlights shaded for air raid–drill patrol suggest an early World War II purchase, before car production was restricted as part of the war effort. (Robert Spirk.)

The house that still stands at 1048 and 1050 Jeter Avenue was built in 1890 by Harry Wachter, who was just 21 years old when he undertook the construction to provide a home for his wife of one year. Livy Wachter is seen on the left with her children. The Knechel family is on the right. (Ronald Wachter.)

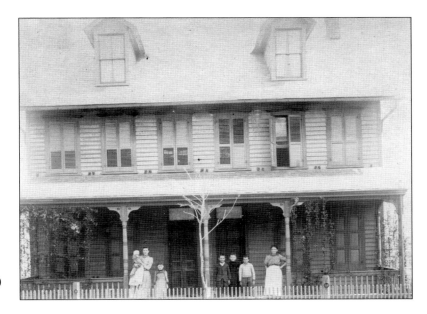

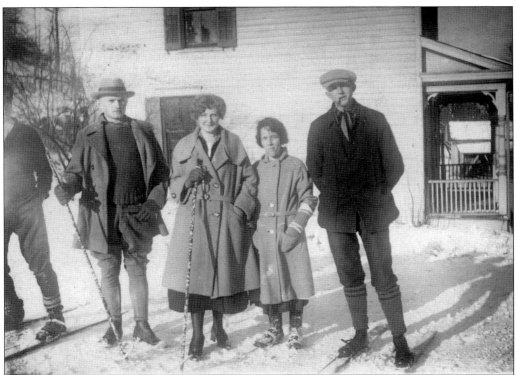

Alfred Miller (right) came to the United States from Dresden, Germany, in 1921. A machinist at Bethlehem Steel, he is seen here with his wife, Elizabeth Gramlich (second from right), whom he married in 1936, and two unidentified neighbors. The Millers moved into a house in the Lechauweki suburb, an area that was so meagerly developed that one could still enjoy skiing on the slopes of former farmland. (Barbara E. and Jean A. Miller.)

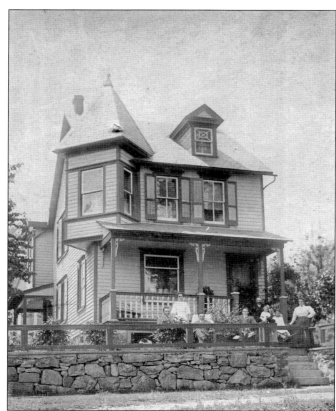

Still standing at the corner of Moravia and Warren Streets, the home of Charles and Laura Diehl was built in 1910. It was one of many houses in the Moravia Heights suburb and the area south of Delaware Avenue that were constructed by brothers Charles and George Diehl and other family members under the name Diehl Developers. (Judy Bloch.)

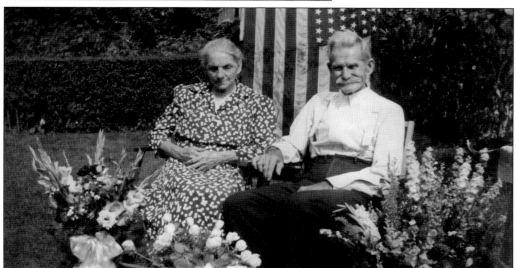

In 1951, Francis and Elizabeth Gramlich celebrated their 57th wedding anniversary at their home on Moravia Street. Born in Germany, Francis came to the United States at age 10. He became a stonemason and worked for 40 years for noted building contractor Benedict Birkel. His stonework can be seen in buildings in South Bethlehem and on the Lehigh University campus. (Barbara E. and Jean A. Miller.)

Bertha Stein and her son Eugene Szabo resided in one side of a double house at 1209–1211 Broadway. The historic house was shown on an 1874 map of the area that identified the street as "the road to Emaus." Bertha was employed as a winder at the silk mills on Seneca Street. (Karol Strelecki.)

Tossing quoits for relaxation or in competition was a popular pastime through the 1930s. During the Great Depression, the borough established quoit courts at the playground and on an open lot on South Lynn Street to provide an outlet for men who were idled by the economic downturn. (David Leidig.)

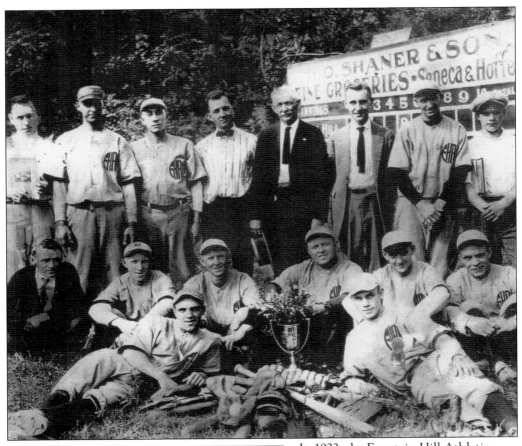

In 1922, the Fountain Hill Athletic Association (FHAA) leased from Robert Pfeifle a property near the borough's tract west of the Wilbur Lawn Golf Course and turned it into an excellent baseball field. The FHAA team first participated in a local amateur baseball league and later turned to playing in the Bethlehem City League. (Fountain Hill.)

This carefree group looking for another day of gamboling through the borough's parks and woodlands includes, from left to right, (first row) Richard Sames, Alvin Schuler, John Spadaccia, and Luther Hottle. The other three are unidentified. Likely haunts would include reservoir park behind St. Luke's Hospital and the wooded areas of South Mountain. (Luther Hottle.)

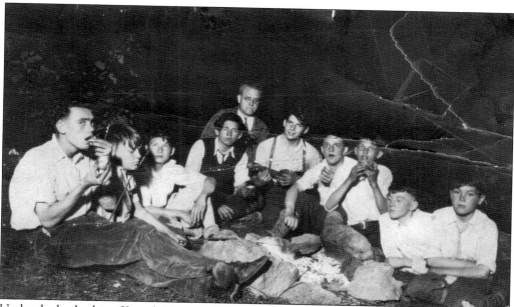

Under the leadership of Joseph Mangan (center rear), a 1931 Boy Scout troop enjoys a campout on the grounds of the former Lechauweki Springs resort. The resort area was in a state of disrepair, but many people, especially the children of the borough, used it for camping, hiking, picnicking, and nature study. (William Fritz.)

After returning from active duty in 1945, Aviation Ordnanceman 3rd Class (AO3) William "Bill" Fritz celebrated with brothers Clayton and Earl as well as his mother, Elizabeth, and youngest brother, Lewis. Bill served with the South Atlantic Fleet Air Wing 16. Among other pursuits during his return to civilian life was a 1960–1964 stint as constable in the borough. (William Fritz.)

Scouting was always an important part of a boy's development on the Hill. Showing off their Minsi Trail Boy Scout Council Merit Award are, from left to right, (first row) John Nonnemaker, Paul Zambo, and Dennis Bright; (second row) Edward Novak and Robert Schade. The Scouts were members of Cub Scout Pack 39. (Fountain Hill.)

This group of young 1950s entrepreneurs includes, from left to right, (first row) Bobby Bruno; (second row) Jack Redding, Mac Jaworski, and Jerry Berger; (third row) Ludge Iasello and Dick Redding. The group met every Sunday on Stanley Avenue to distribute the Sunday editions of the *Allentown Chronicle*, the *Philadelphia Inquirer*, and the German-language *Staats Anzeiger* across the borough. (Jerry Berger.)

Stephen Vincent Benet, the American poet noted for his Civil War poems "John Brown's Body" and "Western Star," was born in Fountain Hill in 1898. His father, a captain in the Ordnance Corps of the Army, had been assigned to duty at the Bethlehem Iron Works. The family left the borough when Benet was just a few months old. (Fountain Hill.)

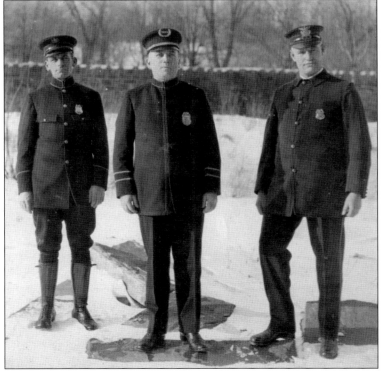

In 1923, following the death of Hugh Burns, the borough's first chief of police, the Fountain Hill Police Department was represented by three men: mounted patrolman Walter Keeler, Chief Victor Kaufman, and patrolman George Bauman, who served the borough for 17 years. Keeler was the son of the borough's first constable, Daniel Keeler. (John Bauman.)

The Schrempels, from front to back, Frances, Martha, and Walter, continued the family tradition of inhabiting 503 Norway Place. Walter owned a coal and ice business in South Bethlehem and served as the director of civil defense during World War II. Martha attended Julliard School of Music and has become a renowned pianist and teacher in the Lehigh Valley. (Martha Schrempel.)

George Milligan, a 1951 graduate of Fountain Hill High School, is the only Hiller ever to attend the United States Military Academy. Milligan, seen here with high school classmates Maryann Ronca (left) and Esther Overdorf (right), graduated from West Point in June 1954 and served as a first lieutenant in the Army during the Korean War. (Esther Overdorf Fresoli.)

Fountain Hill has a long tradition of planting trees to celebrate people and events. Elsie Pribula served the borough in a wide range of efforts, including many related to children and recreation. In honor of her 70th birthday, her husband, Joseph, had this tree planted on Earth Day in 1994 at Lechauweki Springs. (Pauline D. Holschwander.)

From left to right, four of the six male members of the Guman family, Joseph Jr., Patrick, father Joseph Sr., and Donald, pose in their Easter best outside their home on Lynn Street. Joseph Jr. and Donald chose to attend Allentown Central Catholic High School while Patrick earned his diploma at Fountain Hill High School. (Gerald Guman.)

Among many from the Hill who were awarded Purple Hearts, the oldest military award still given to members of the Army, Marines, Navy, and Air Force, is Amandus G. Schaffer, who, at the time he earned this recognition, was a corporal in the 4th Weapon Platoon, Company K, 320th Infantry Regiment of Gen. George Patton's Third Army. (Betty Jane Shaffer Damhosl.)

Christmas and Easter were always special times at the American Legion Post. With the waning fortunes of the famed Hess Brothers department store in Allentown, the post contrived to purchase the Santa Claus and Easter Bunny costumes that had been traditionally used at the Hess store. From that time on, they graced the seasonal celebrations at the Legion building. (Post 406.)

To brighten the borough for the celebration of its centennial anniversary, the Exchange Club undertook the task of painting every flagpole within its limits. William DeAngelis was in charge and is seen here in the hydraulic lift that toured the streets to complete the task. (Robert L. Hunter.)

One of three triangles in the borough, the Memorial Triangle on Stanley Avenue is dedicated to those who have served in the US military. Rites are held here on Memorial Day by Post No. 406 of the American Legion, complete with a 21-gun salute. In 2014, all of the memorial crosses were refurbished as an Eagle Scout project by William Walsh of BSA Troop 146. (Robert L. Hunter.)

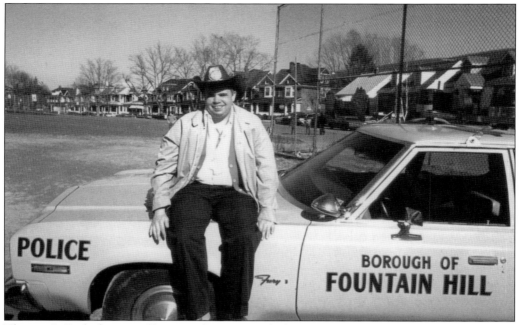

Thomas LaBuda, known affectionately as "Mot" for his propensity to write his name backwards in elementary school, has been a fixture in the borough since 1962. No significant event occurs without his presence and engaging smile. He has been lovingly cared for by a coterie of the Hill's residents. (Robert L. Hunter.)

Earl "Noodles" Dreisbach, a 1951 Fountain Hill graduate, became the first Hiller to play professional baseball when he signed a minor league contract with the St. Louis Cardinals in 1953. He is seen here at the Cardinals' minor league spring training camp before leaving to play the 1956 season for the Hannibal (Missouri) Cardinals. (Edward Dreisbach.)

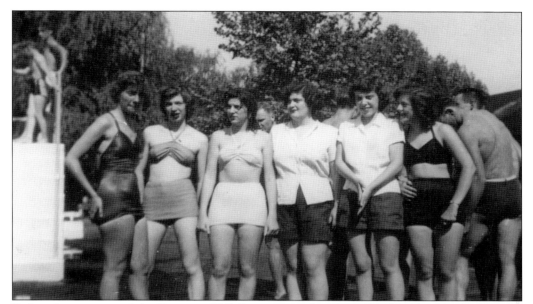

Before the opening of the Fountain Hill Community Swimming Pool at the Stanley Avenue recreation area, Hillers trudged a long way for a refreshing summer swim. This group, consisting of, from left to right, Joan Donatelli, Lucille Wagner, Mary Anne Ronca, Muriel Isralite, Esther Overdorf, and Lori Ronca is seen at the spring-fed Hiawatha Pool on Seidersville Road, near Hellertown. (Esther Overdorf Fresoli.)

From the very beginning, Fountain Hill benefited from the leadership of the strongest and most dedicated residents. Their ability to look beyond individual interests and proclivities and plan wisely for the future produced an environment ripe for growth. This group included, from left to right, Howard Kuhns, Earl Bauman, Leonard Eddinger, Thomas Redding, Fountain Hill mayor Robert McGovern, borough council president Ervin Wohlbach, Patrick Lynch, and an unidentified consultant. (John Bauman.)

The 1950 Fountain Hill Borough Police Force shows off its recently acquired Chevrolet police cruiser and spiffy new uniforms. From left to right are patrolmen Roy Hoffert, William McDermott, Karl Wied, and Harris Wilson, chief of police Gustave Harrison, and burgess Robert McGovern. (Fountain Hill.)

F.J. Simons, the commander of Fountain Hill American Legion Post No. 406, prepares to lead the World War II victory parade through the borough in 1945. The post also sponsored a welcome home parade for all servicemen in the area and put on the first Armistice Day parade in the Lehigh Valley. (Post 406.)

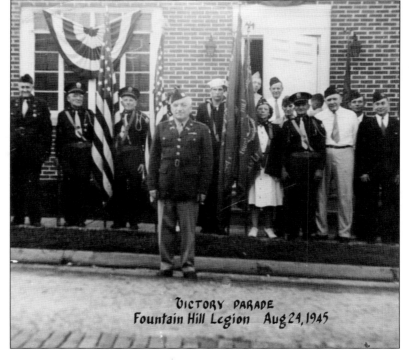

VICTORY PARADE
Fountain Hill Legion Aug 24, 1945

The 1971 Post No. 406 baseball team advanced further in the state American Legion baseball playoffs than any other Fountain Hill team. This team photograph is signed by Bobby Thomson, whose "shot heard 'round the world" home run won the 1951 National League championship for the New York Giants. Thomson was the main speaker at a celebratory dinner for the Fountain Hill team. (Robert Spirk.)

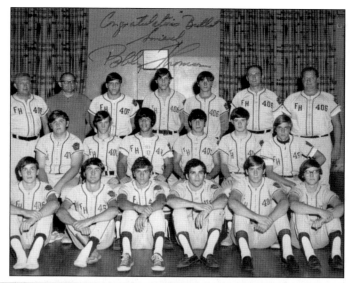

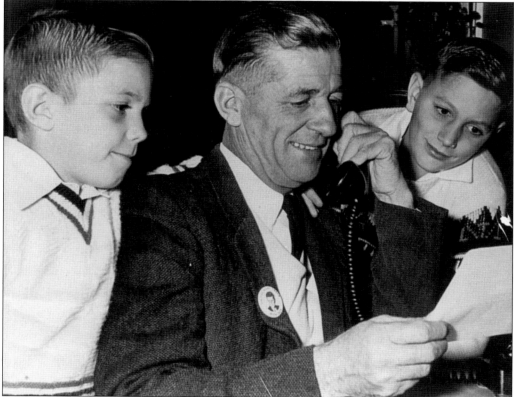

Beginning with the 1904 presidential election, the residents of the first ward cast their votes for the winning candidate until 1968. Lehigh County Democratic Party chairman Joseph J. Spirk is seen here in 1960 calling the Hyannisport compound to indicate that the ward had cast 61 percent of its votes for John. F. Kennedy. Spirk's sons Robert and Jody are at his side. The string of bellwether votes was broken eight years later. (Robert Spirk.)

In 1968, chief of police Karl Wied, a 35-year veteran of the police department, demonstrates the newly installed Bell Telephone central alarm system. The call box system enhanced communication of fire and police responses within the borough's boundaries and with adjoining entities. (Kenneth Weid.)

Fountain Hill historian and promoter Edward J. Redding leads the 1993 centennial parade down Delaware Avenue. With his encouragement and leadership, the borough had a reawakening to its historical presence. Redding is the author of the second historical account of the borough, *The History of Fountain Hill, Pennsylvania.* (Jack Ferry.)

Six

OUR RENEWAL

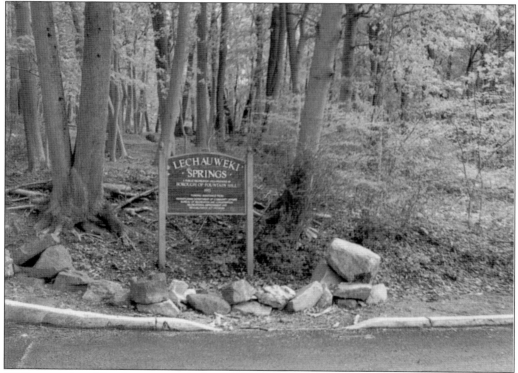

Well remembered but long ignored, the Lechauweki Springs resort area created by John Smiley was given new life when Fountain Hill celebrated its centennial in 1993. In concert with Lehigh County, which purchased five acres for the new park, a gazebo that marked the original pond area was re-created, signage was put in place to identify original buildings, and trails were reopened for hiking. (Pauline D. Holschwander.)

This house at 821 Dodson Street was built in 1788 by Nicholas Ueberroth, who had acquired the 156-acre farm of Nicholas Doll, one of the earliest settlers in this part of Salisbury Township. Like so many other old and venerable structures in the borough, it has been renovated by its current residents to reflect as many of its original features as possible. (Guy and Mary Maioriello.)

A Pennsylvania Historical and Museum Commission marker in front of the brick house at 827 North Bishopthorpe Street identifies it as the birthplace of author Stephen Vincent Benet. He lived here only a few months after his birth in 1898. The building now serves as office space for the St. Luke's University Hospital Network. (David Strelecki.)

Now an apartment house at 732 Seneca Street and almost hidden among an array of row houses and single-family dwellings added to the block over the years, this building was originally constructed to house the James Private Hospital and the offices of medical practitioner J. Edward James, MD. (Karol Strelecki.)

Long a central meeting place on Broadway at Lynn Street and always the site of the borough's Christmas tree, this plot became another focal point of the 1993 centennial celebration when it was officially designated as the Tinsley Triangle in honor of Tinsley Jeter, who is often referred to as the "Father of Fountain Hill." (Pauline D. Holschwander.)

When the original Municipal Building on North Clewell Street became outdated and overtaxed, a decision was made to relocate to this site on Long Street, in the rear of the historical Lehigh Valley Silk Mill. Fire department services were moved to a newly built structure directly to the south on Cherokee Street. (Fountain Hill.)

The plot of land bounded by Delaware Avenue and Fiot, Seneca, and Mohican Streets was the province of Truman Dodson and his heirs. In 1970, the mansions in which they resided were demolished, replaced by the Lehigh County Cedarbrook Nursing Home. Proximity to St. Luke's University Hospital was a significant factor in the location of the short- and long-care facility. (Karol Strelecki.)

Since its inception, the Fountain Hill Cemetery has adapted to the ethnic and religious groups who have sought it out as a place of last repose. In 2010, a new section named Green Meadows was opened to offer an opportunity for a natural burial, which foregoes the trappings that have become customary for interments. Fountain Hill was the first Lehigh Valley site to offer such an opportunity. (Fountain Hill Cemetery.)

Since 1928, this playground has filled the space on Stanley Avenue at South Lynn Street. It has steadily evolved to meet the interests of the youth of the borough, who now refer to it simply as "the park." The one constant has been the large trees on its eastern edge, many of which were planted when the area was first developed for recreation. (Karen Strelecki Jones.)

Popularly referred to as Fountain Hill Elementary School, the old high school that was renovated by the Bethlehem School District in 1973 was formally named John S. Spirk Elementary School in recognition of Spirk's service as a longtime educator and community leader. It now serves students from both the borough and parts of South Bethlehem. (Fountain Hill.)

Dwindling participation in the American Legion program dictated that Post No. 406 abandon its longtime headquarters on Broadway. The building now bears the name The Epic Center. It is the home of the Epic Church, a family- and community-based faith. The church offers a wide range of activities for children and adults. (Epic Church.)

Once Muhr's Meat Market on Broadway at Smiley Avenue, Lorenzo's Pizza, owned and operated by the Lo Piccolo family since 2009, now offers a different epicurean experience. Its Italian cuisine is every bit as enticing and up-to-date in the 21st century as Muhr's offerings were in the mid-20th century. (Lo Piccolo family.)

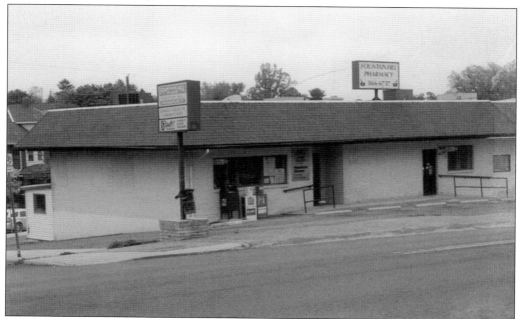

The demise of trolley service on Seneca Street made the home of Reppert's and Hunsicker's Pharmacies less accessible and desirable. The Fountain Hill Pharmacy has now moved to Broadway at Hoffert Street, where it has increased visibility and expanded parking for its clientele. The quality of customer service has not waned. (Fountain Hill Pharmacy.)

Shopping centers and large-scale grocery stores hastened the closure of the 19 family enterprises that once served borough residents. The Bottom Dollar grocery chain, on the site of the former Fountain Hill Beneficial Society, represents the new normal for grocery shopping in Fountain Hill. (Donald Benner.)

A small strip mall at the eastern end of the borough with outlets offering Hispanic cuisine reflects a changing cultural dynamic that is appearing not only in the area abutting South Bethlehem, but also in other segments of the borough. The site of the mall is the property that held the Hellener farmhouse in the early years of the borough. (Karol Strelecki.)

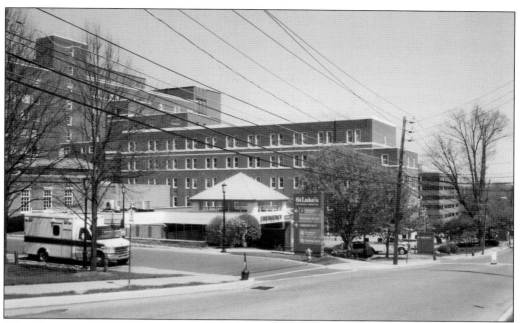

What began as St. Luke's Hospital has now developed into the St. Luke's University Health Network, with six campuses and multiple outpatient facilities across the Lehigh Valley. This view east on Ostrum Street represents the continuing development of the Fountain Hill campus. Homage is paid to its origins in some of the new construction's adaptation of original building concepts. (Karol Strelecki.)

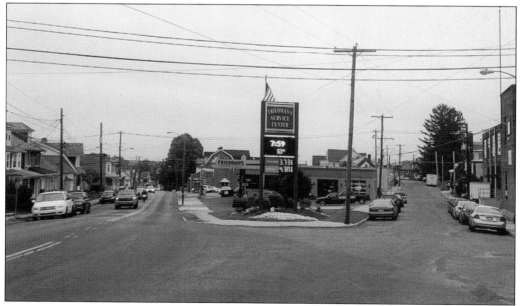

After more than 70 years, the Friedman family remains the only family enterprise that continues to serve the borough of Fountain Hill, purveying its Texaco products and trusted service from the same site on Broadway on which it was first established. Buildings have changed and faces have changed, but pride in Fountain Hill emanates from the original borough triangle. (Friedman family.)

DISCOVER THOUSANDS OF LOCAL HISTORY BOOKS
FEATURING MILLIONS OF VINTAGE IMAGES

Arcadia Publishing, the leading local history publisher in the United States, is committed to making history accessible and meaningful through publishing books that celebrate and preserve the heritage of America's people and places.

Find more books like this at
www.arcadiapublishing.com

Search for your hometown history, your old stomping grounds, and even your favorite sports team.

Consistent with our mission to preserve history on a local level, this book was printed in South Carolina on American-made paper and manufactured entirely in the United States. Products carrying the accredited Forest Stewardship Council (FSC) label are printed on 100 percent FSC-certified paper.

MADE IN THE USA